SOLOMON'S HOUSE

the lost children of Nicaragua

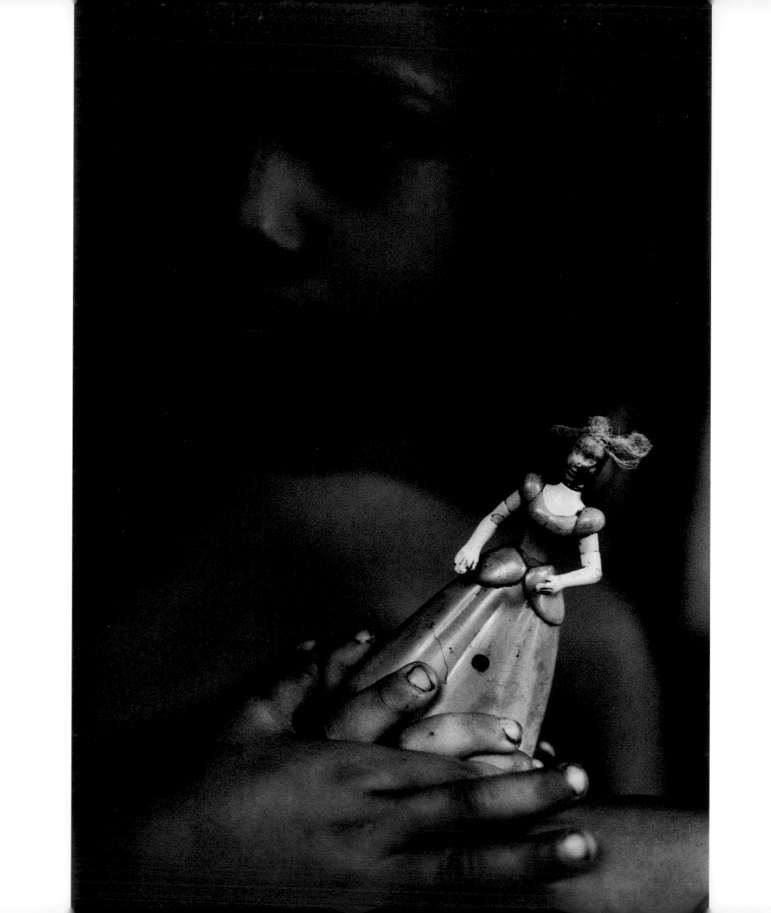

SOLOMON'S HOUSE

the lost children of Nicaragua

photographs and text by Henrik Saxgren
preface by Bianca Jagger

Aperture

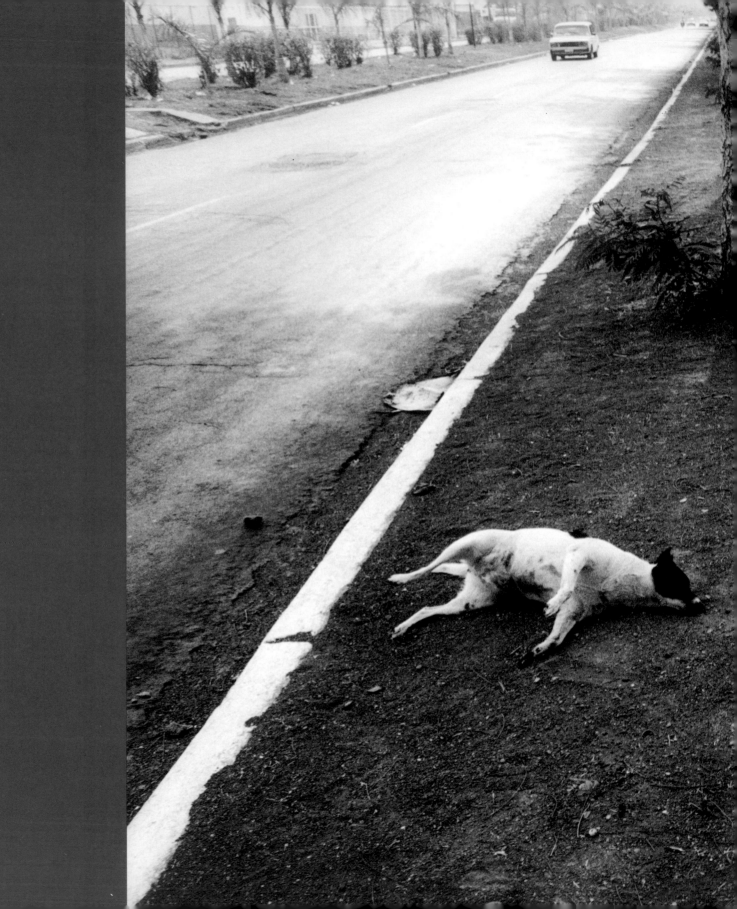

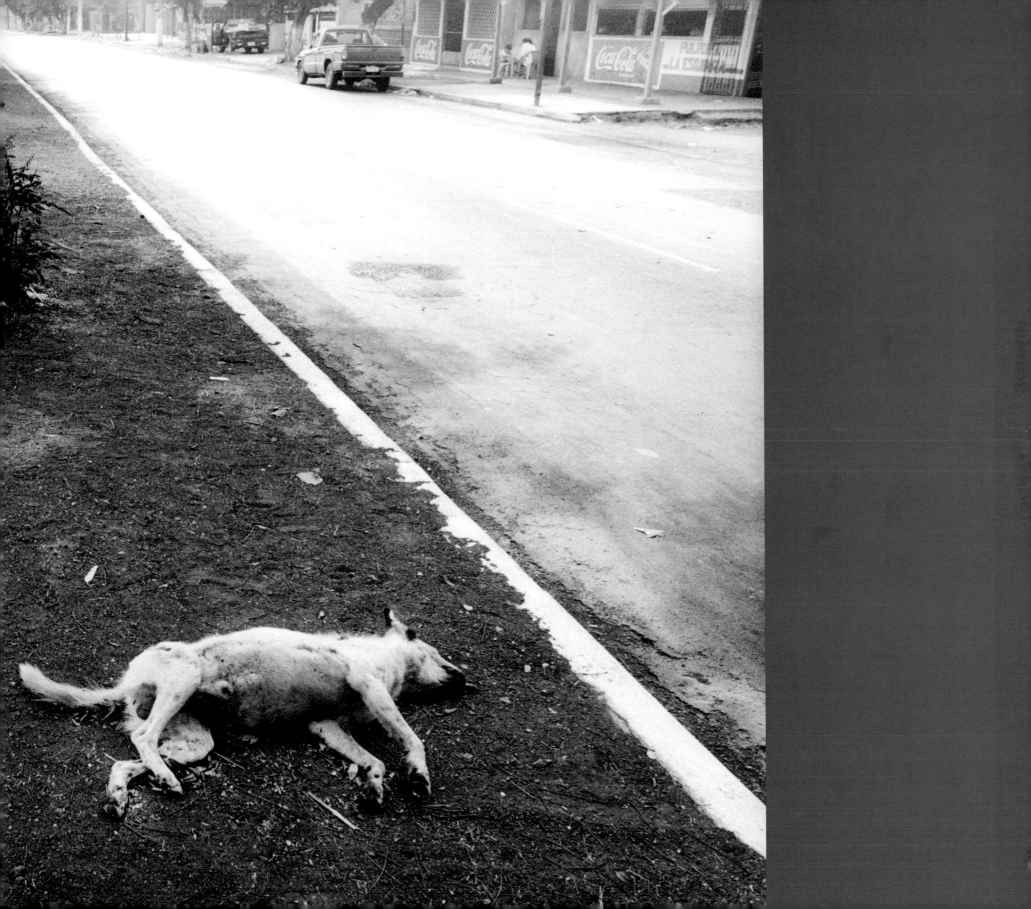

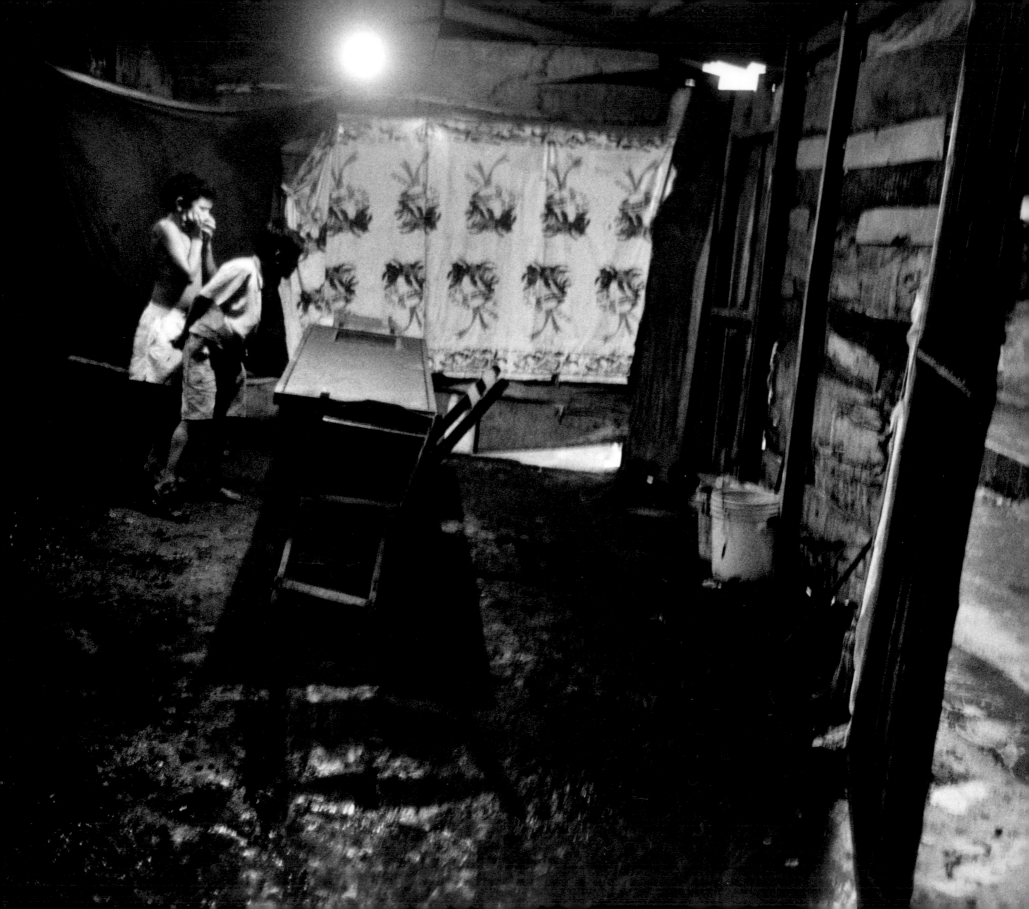

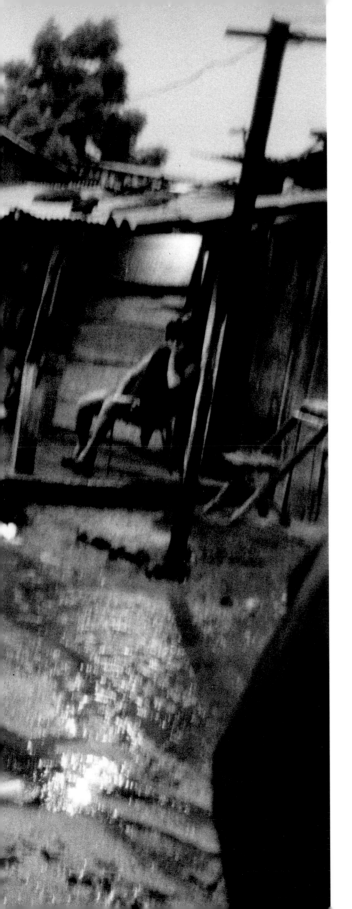

Left and above: Callejón de la Muerte

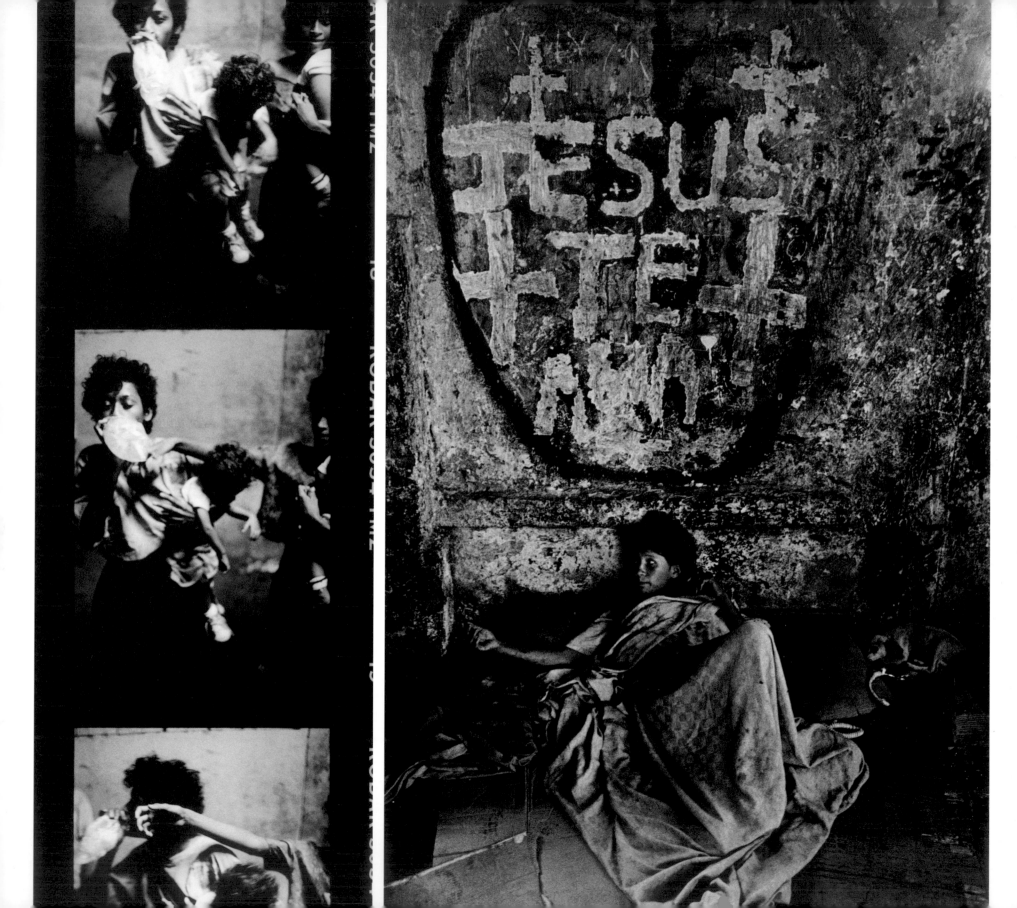

preface *by Bianca Jagger*

Nicaragua: over the course of time this beautiful, ravaged country has been the locus of destruction and creation, devastated both by natural and political disasters, earthquakes, hurricanes, volcanic eruptions, invading foreign powers, and revolutions. Before the uprising of the late 1970s, it was a country in despair. For a short while, after the triumph of the Sandinista revolution, it was a hopeful land where people believed in the possibility of socio-economic justice. Their hopes were soon shattered. It is a country that, despite high rates of illiteracy, has produced a wealth of poets: Ruben Darío, Ernesto Cardenal, Salomon de la Selva, and many others. It was this country, my country, that Henrik Saxgren visited in order to create haunting, revelatory images to catalyze those who reside elsewhere; those who have never lived in war zones.

Nicaragua is no longer officially a war zone. Its war has formally ended. The U.S. no longer backs counter-revolutionaries in its attempts to overthrow the Sandinista government. This government toppled anyway; it was weak from years of struggle, sanctions, and warfare, and it too succumbed to corruption.

The first time Henrik Saxgren went to Nicaragua it was shortly after the insurrection that overthrew President Anastasio Somoza and led to the Sandinistas' rise to power. He witnessed an energized people in what seemed a recovering land. Saxgren returned after the Sandinista government was unseated, in the early 1990s. Nicaragua was transformed yet again by war. He was compelled to document this descent into hell, where girls traded their bodies for shelter, boys slept in trees and carved each other up with knives only to stitch one another together again. Sadly, this is not over. Today, lost fathers, burned fields, broken water pipes, and vacant schools persist. (continued on page 12)

Far left: The twins, María and Carolina, with their babies in the market at night.
Left: María Teresa sleeps in La Casita.

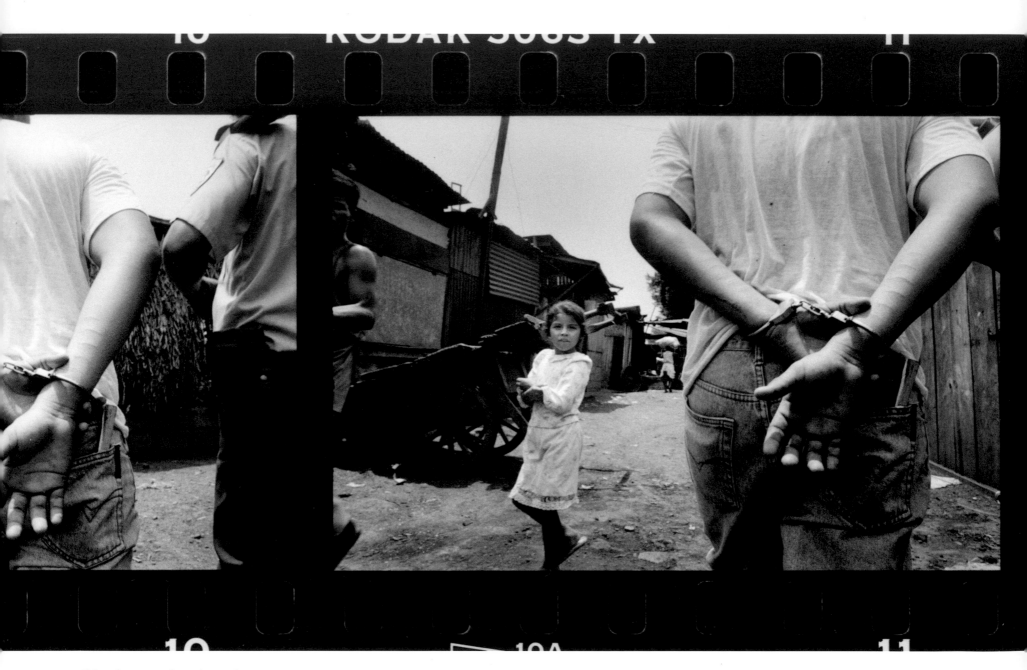

Taken into custody at the market

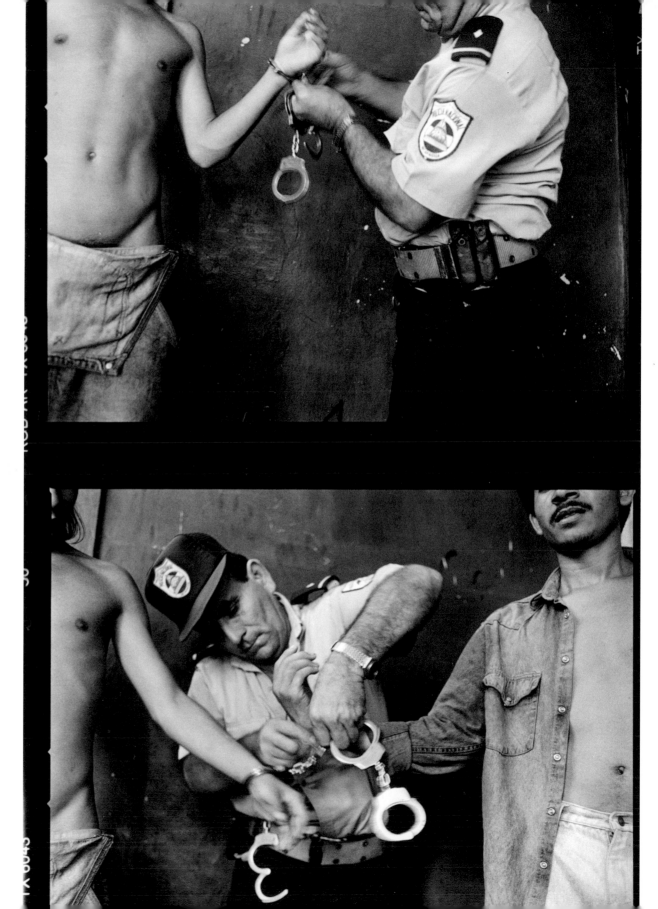

(continued from page 9) Some of the photographs in this book are quite shocking. I cannot look at them without some reservations. I ask myself, what is to be gained by focusing attention on such vulnerability and loss of innocence? Why photograph these naked bodies, which have been sacrificed to street violence and prostitution? Do we threaten to rob these poor children of their dignity and self-respect?

Saxgren's powerful photographs force us to examine the pain of an entire generation of children at risk. They insist that we respond, that we do more than simply stare. They demand that we take action, and they suggest hope: the white scar glowing from the healing wound on a girl's belly, the cast on a child's leg, a boy unscathed. Can a clean bed, a decent meal, a bathroom, and the possibility of education dispel some of this darkness? Can these girls trust again? Can they reap love without barter? After we have looked at every picture and asked ourselves these questions, there is one critical question remaining: how can we possibly choose apathy and inaction now that we have been made witness to this suffering—now that we are no longer ignorant? ∎

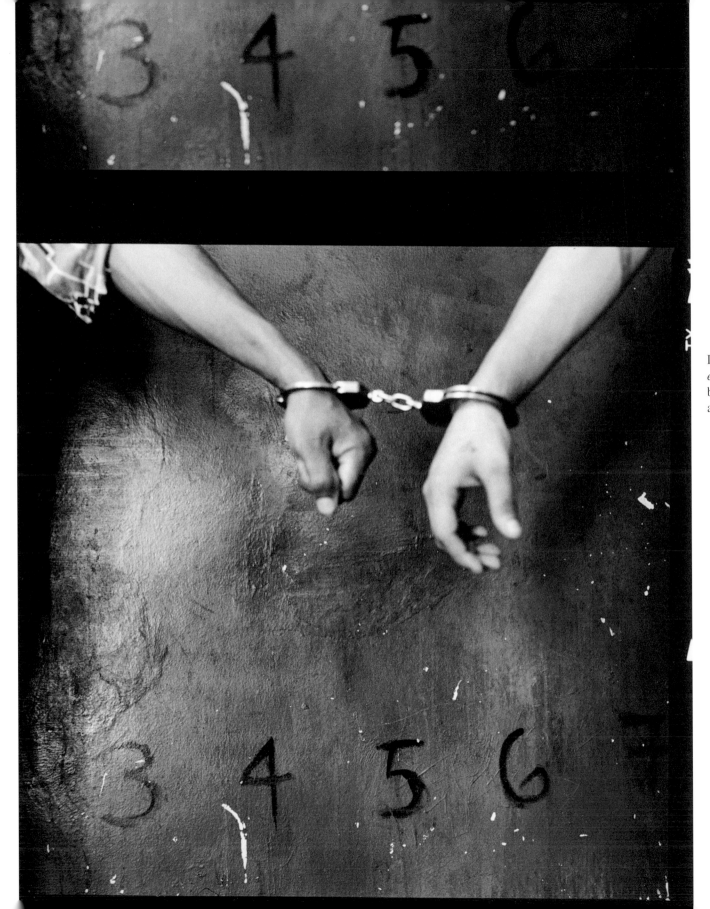

In Spanish, the word *esposas* means wives, but it means handcuffs as well...

13

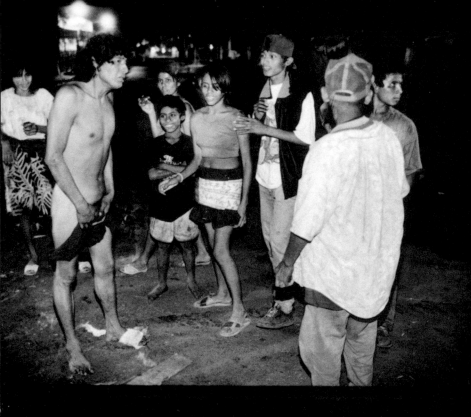
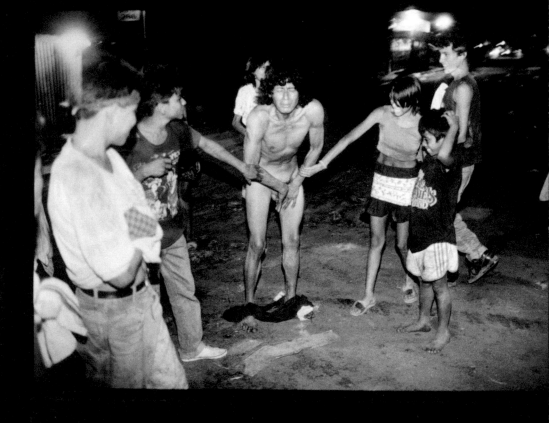

9A 10 10A 1

14 Street kids humiliate El Cochón Llorón, "The Crying Gay."

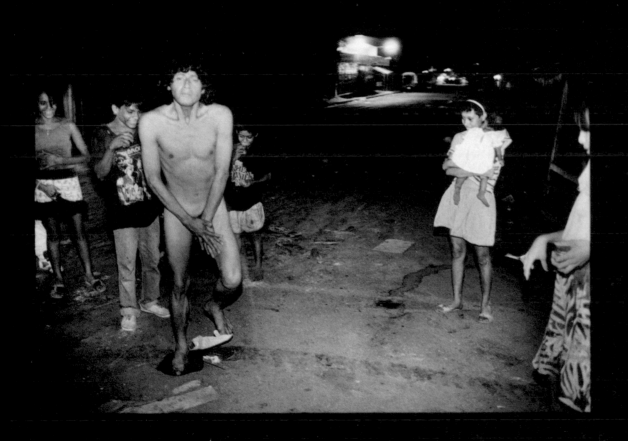
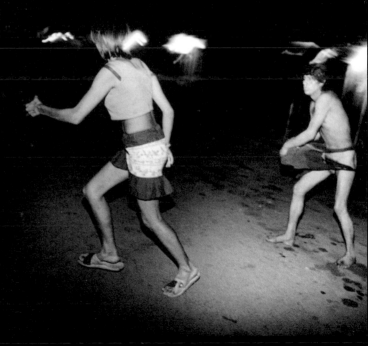

In Nicaragua's capital, Managua, homeless children and weary prostitutes try to make ends meet. Unlucky in the lottery of life, they have drawn losing tickets. Crime and violence leave their brutal marks on every association, every intimacy.

The Catholic Church stresses the importance of monogamous relationships and the authority of fathers, yet more than a third of urban Nicaraguan households are headed by women, and relatively few couples formalize their marriages through the church or state. Married men frequently try to retain more than one household, with very poor results. The church's resistance to contraception exacerbates high birth rates, which continue to escalate the predicament. Many men spend extended periods away from home when harvesting coffee in Costa Rica and elsewhere, and it is during these times that they often abandon their families.

Once abandoned, many women and children have only one resource remaining—their bodies. Although they see their bodies as their sole means of survival, they seem determined to destroy them.

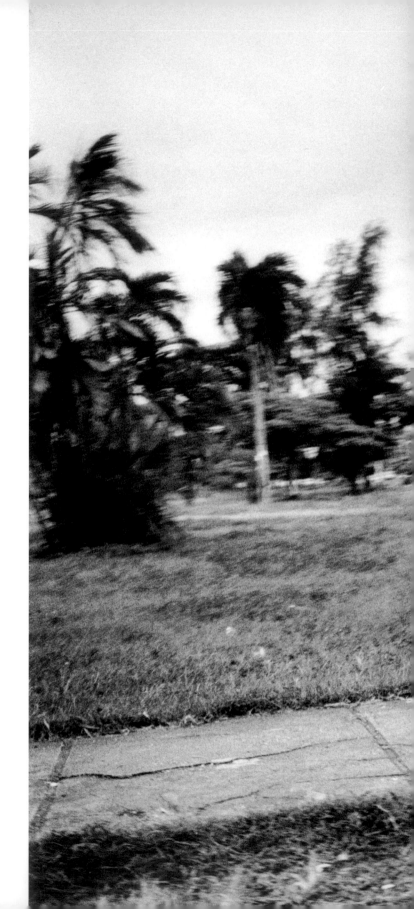

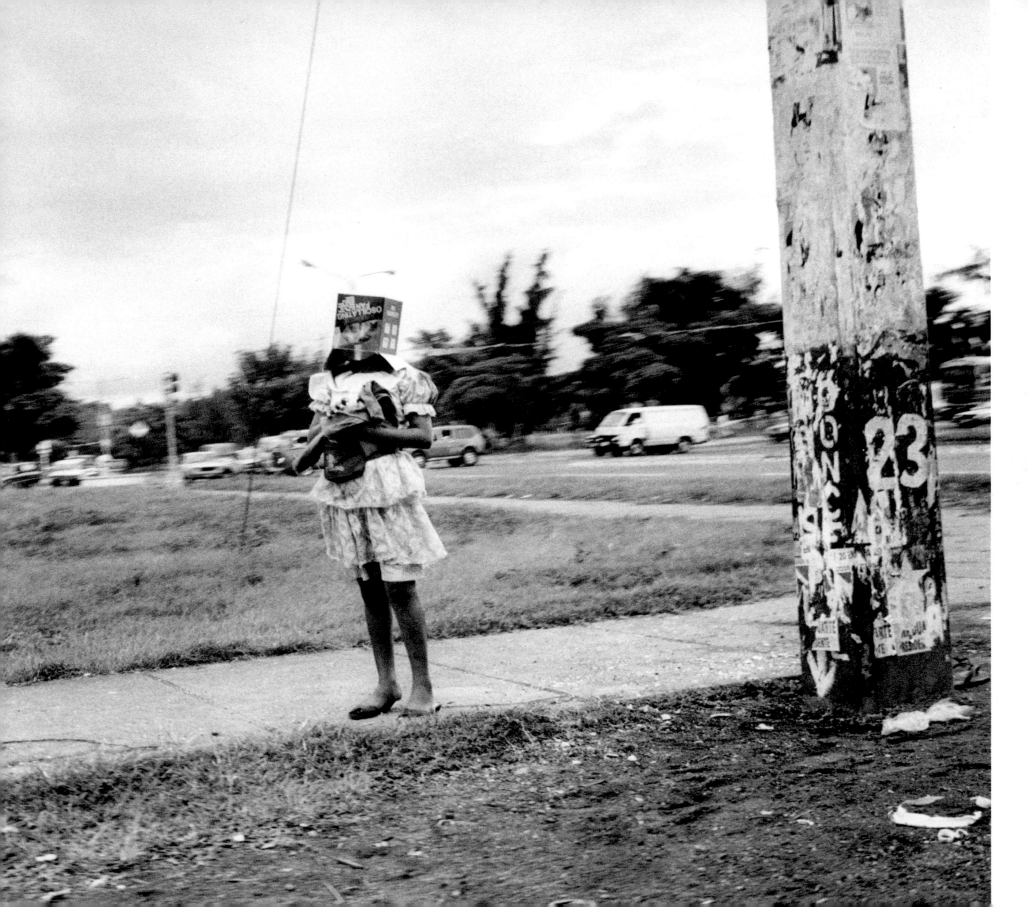

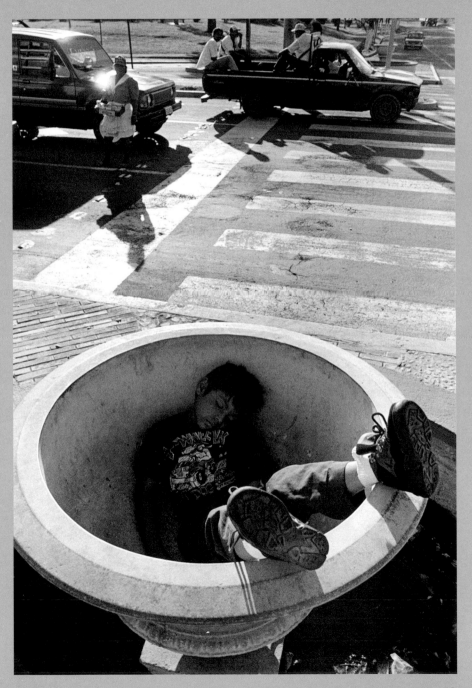

Left, above, and previous pages: Downtown Managua

19

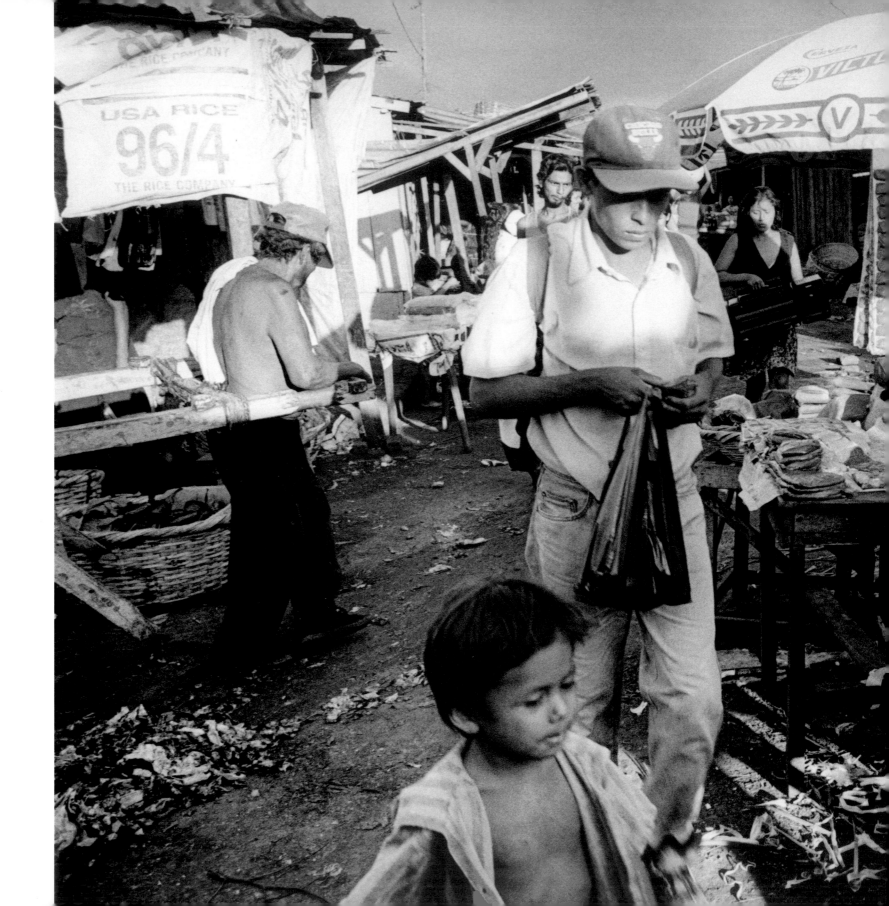

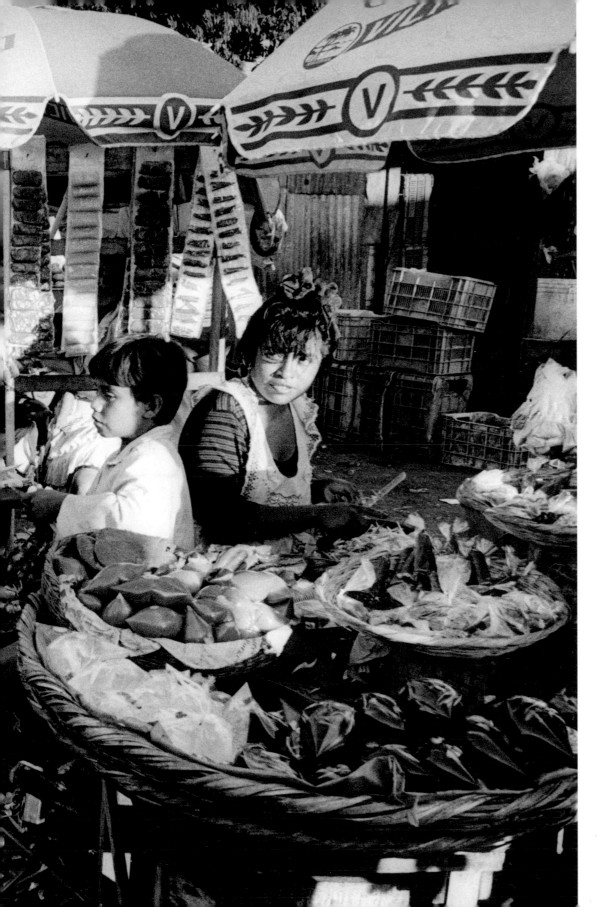

Left and following pages: Mercado Oriental 21

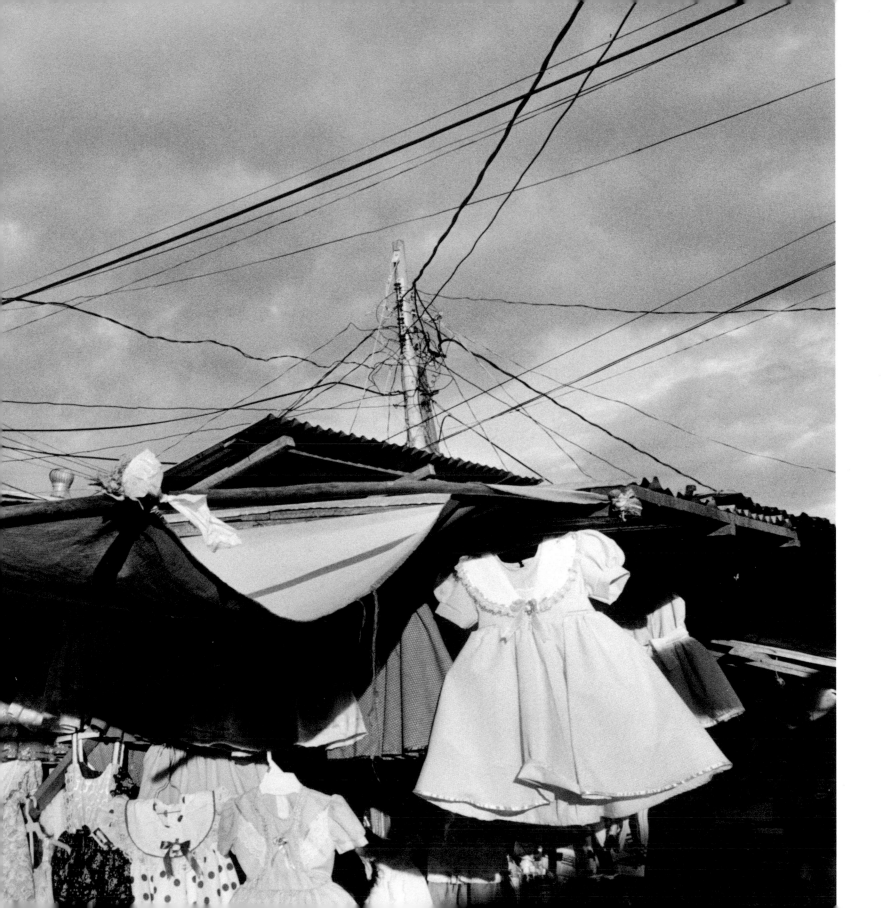

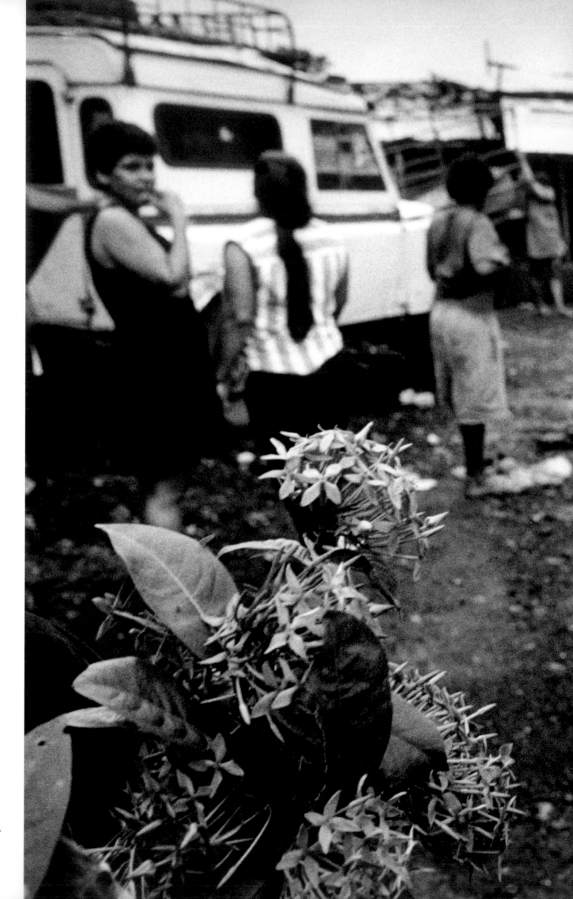

Maritza, a transvestite,
lives in Callejón de la Muerte.

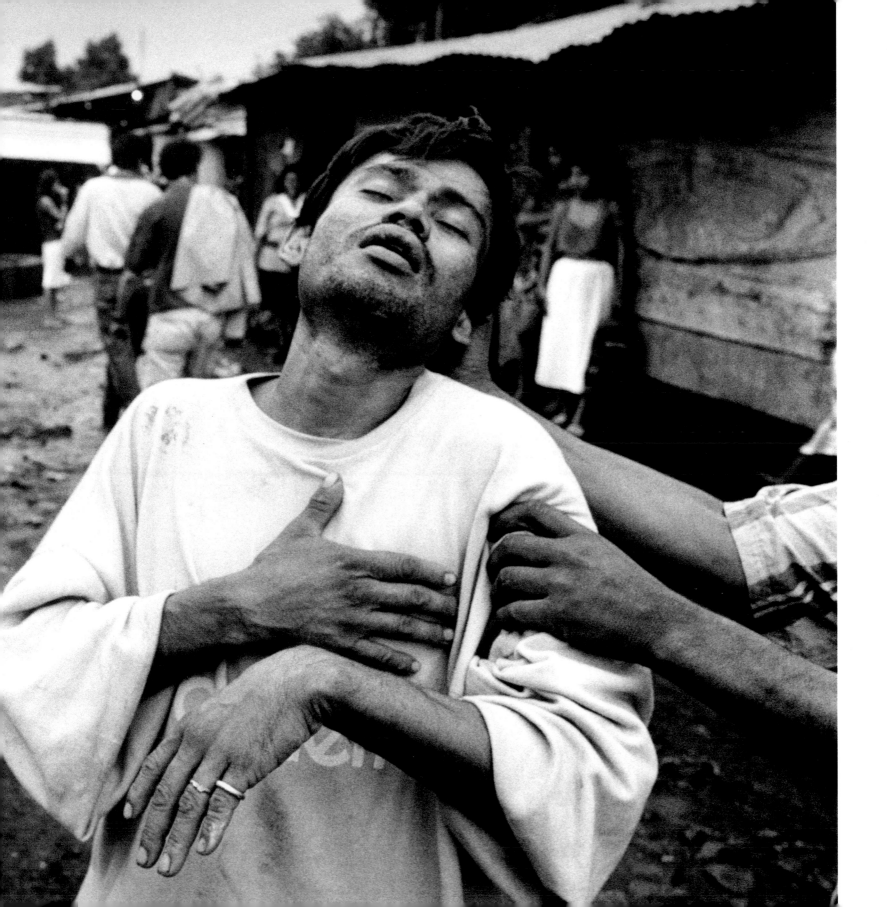

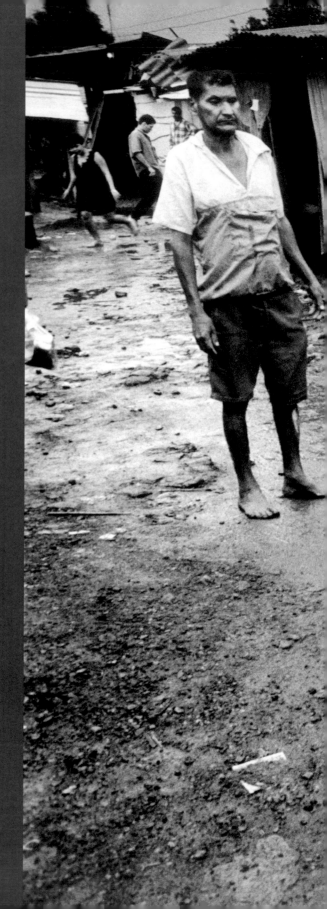

26 Callejón de la Muerte

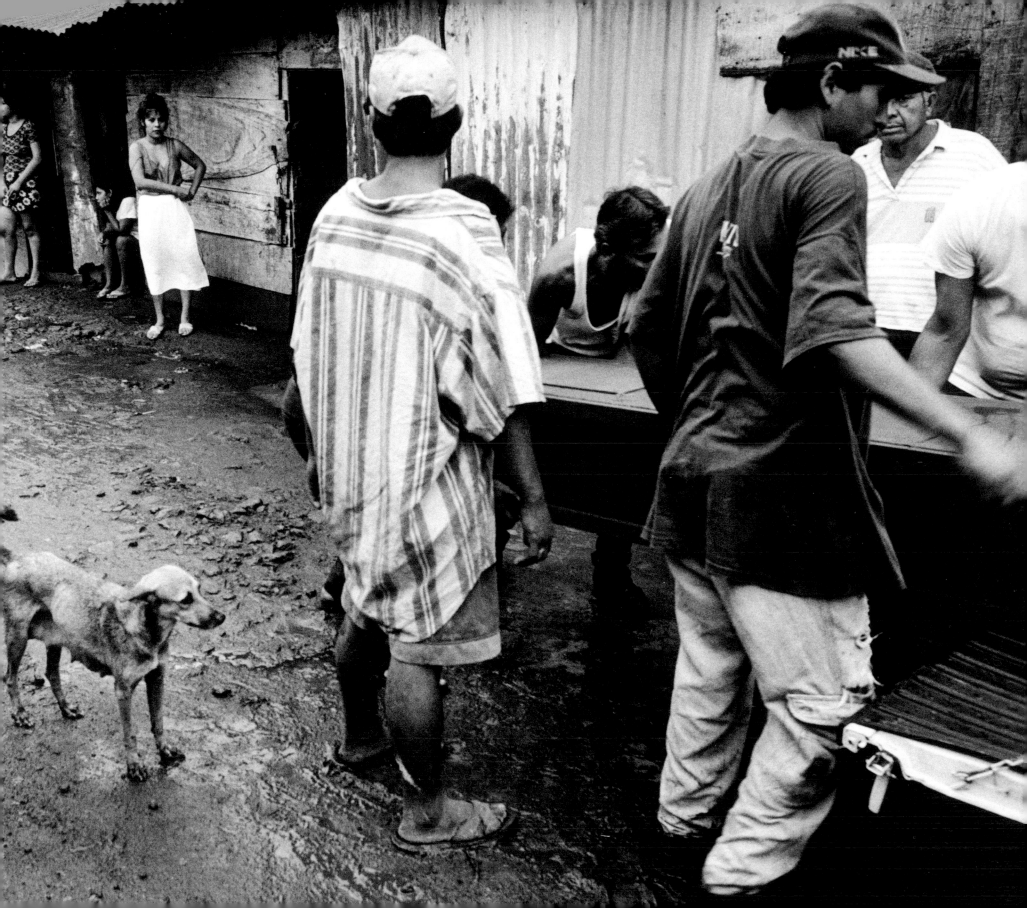

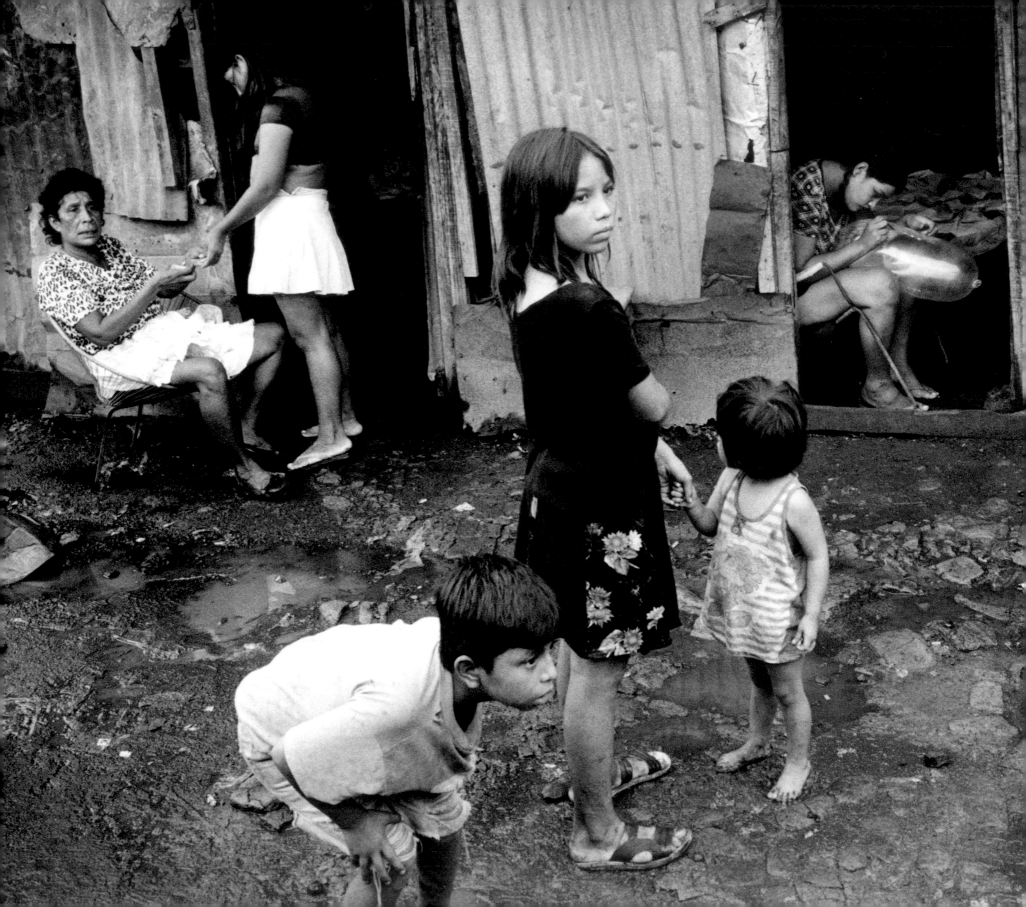

Left: Callejón de la Muerte
Following pages, left and bottom right: Darling (12) at Ometepe
Following pages, top right: Callejón de le Muerte

29

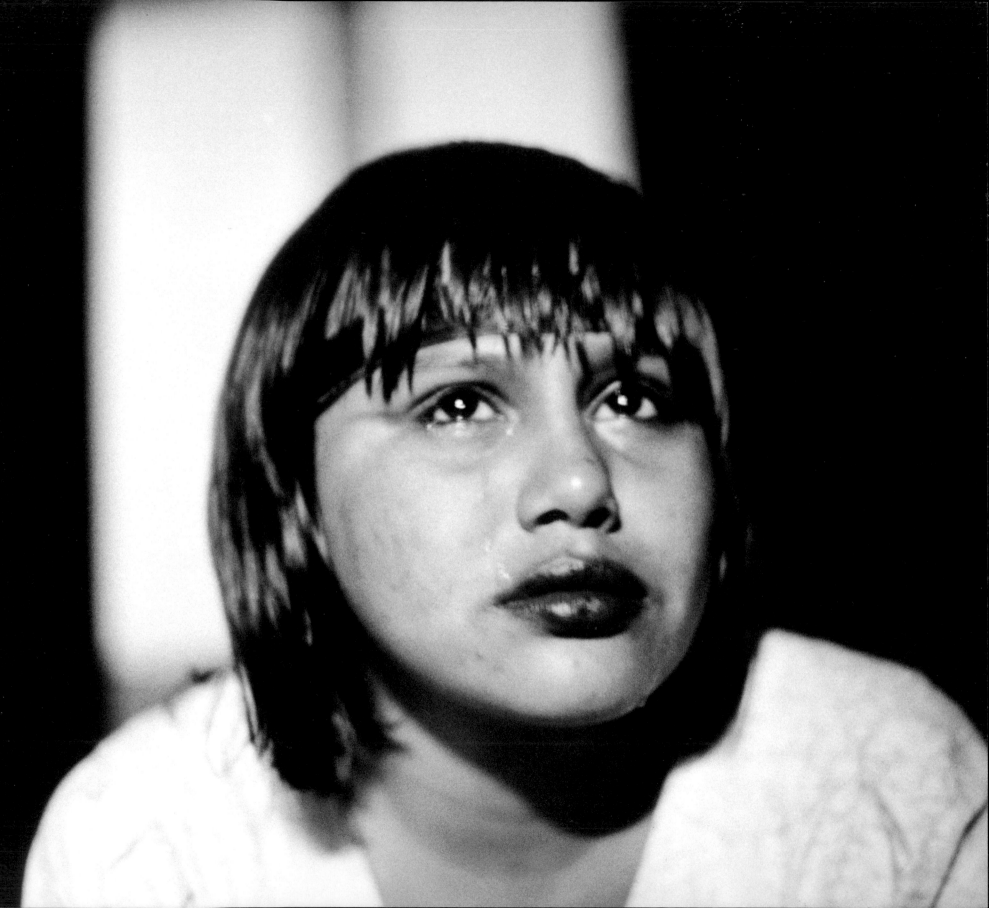

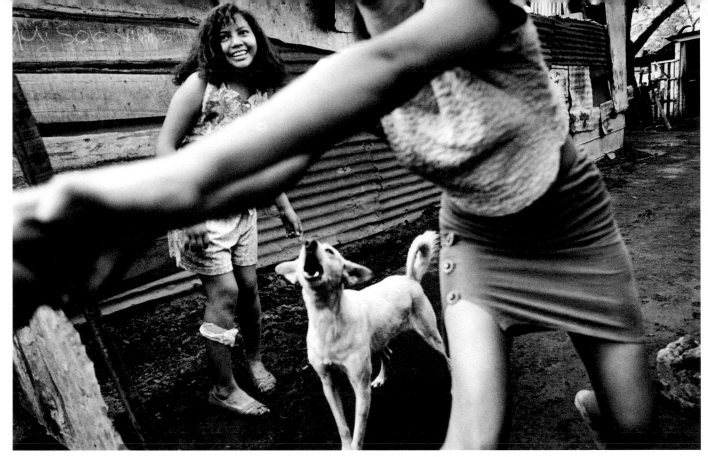
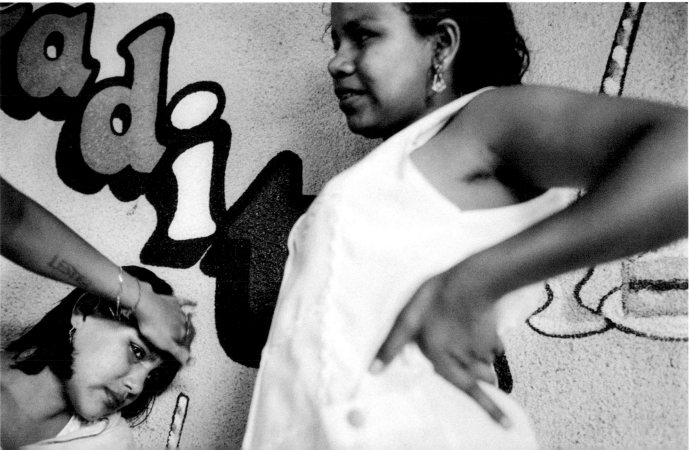

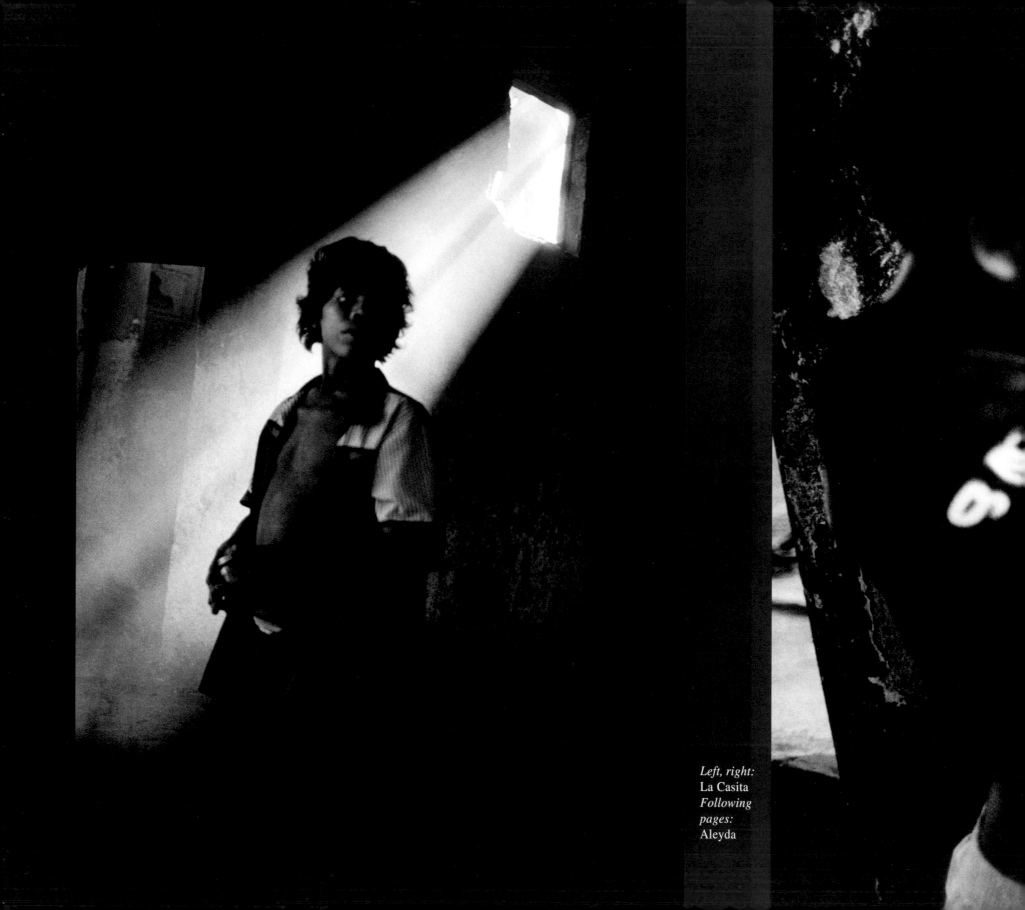

Left, right:
La Casita
Following pages:
Aleyda

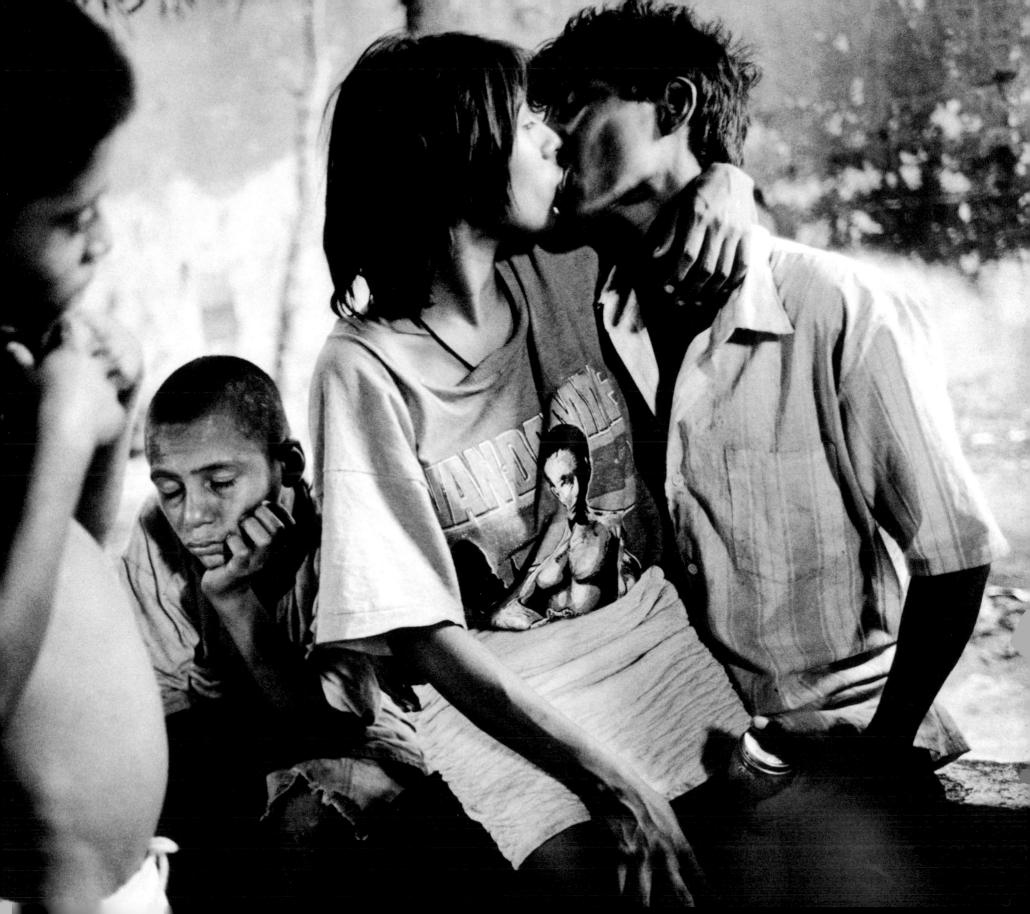

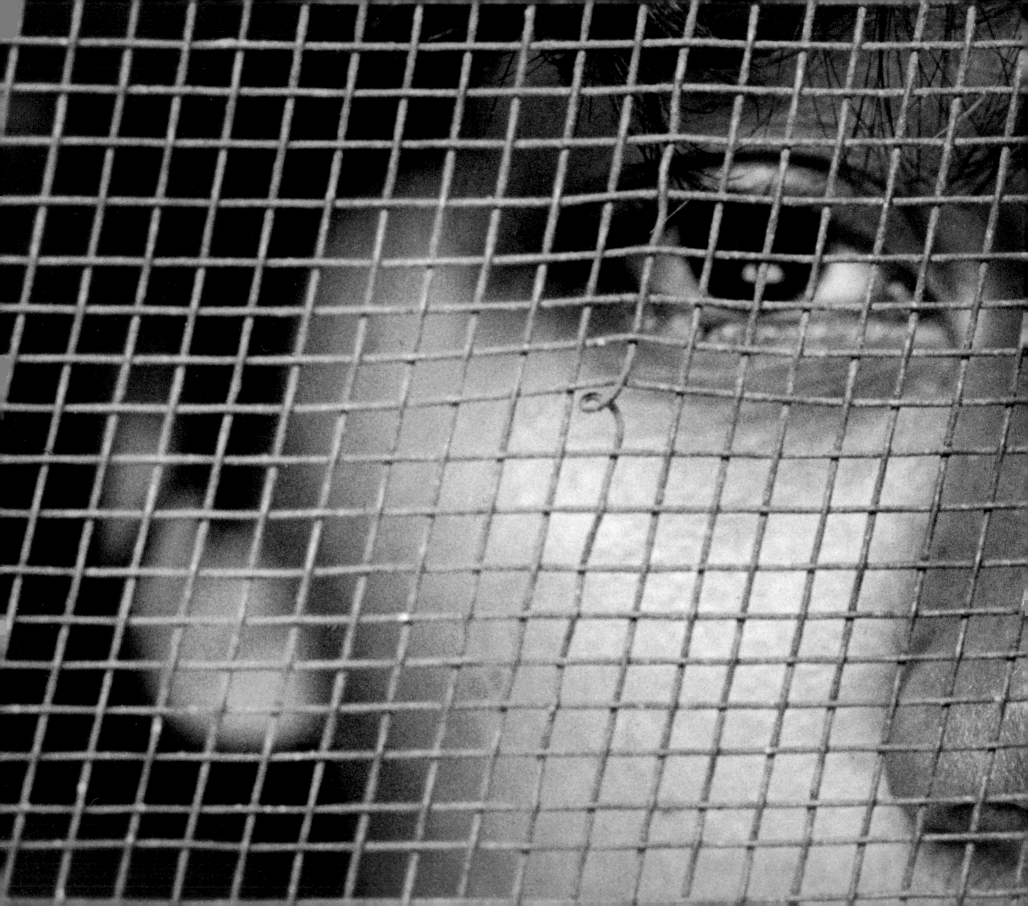

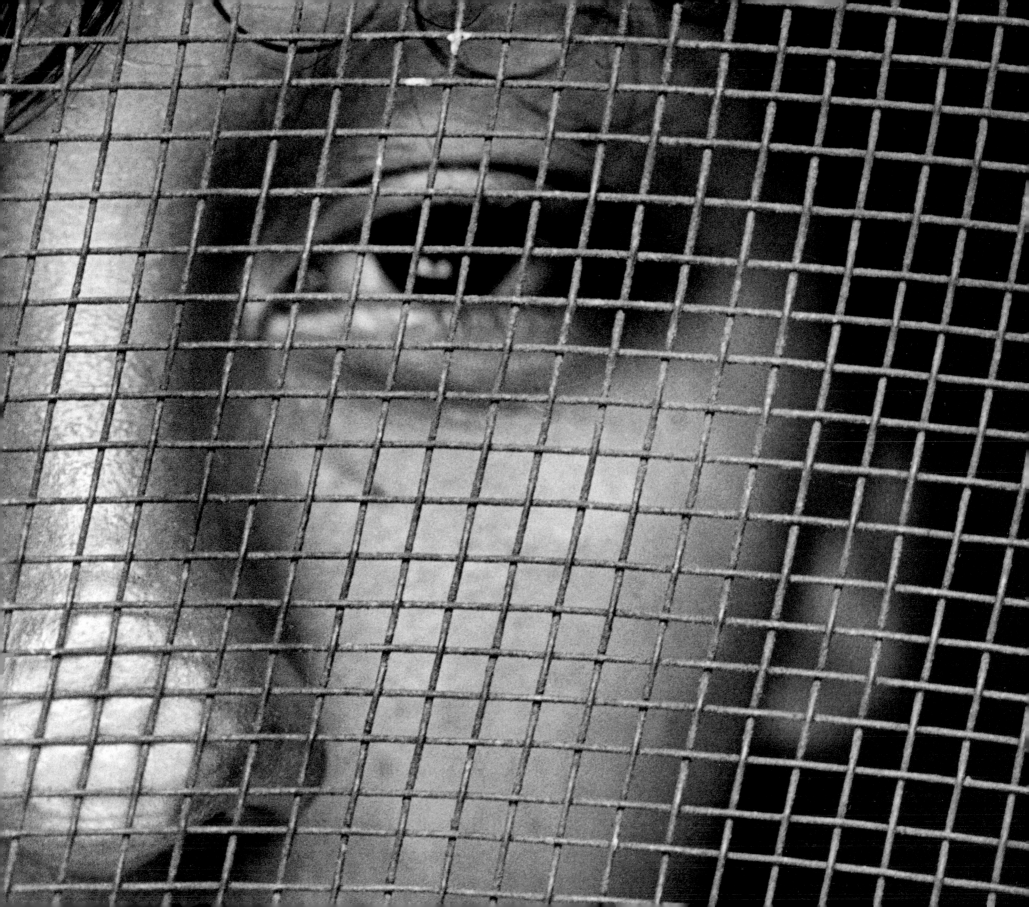

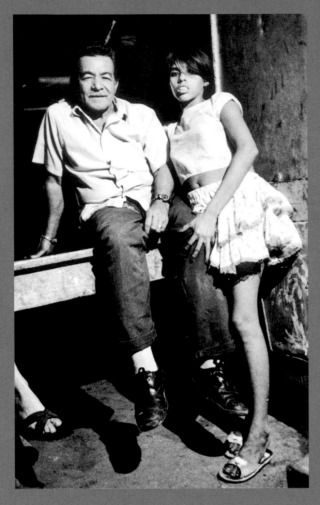

Don Pedro and
Sonia Mercedes (14)

Don Pedro's House

Don Pedro is a poorly paid night guard at the market. The girls are a welcome interruption during his long night duties. Not only does he meet girls at the market; for years, three or four of them at a time have lived in his house.

Jury is his long-timer. I first met her in Don Pedro's house in January 1995. She was twelve years old then.

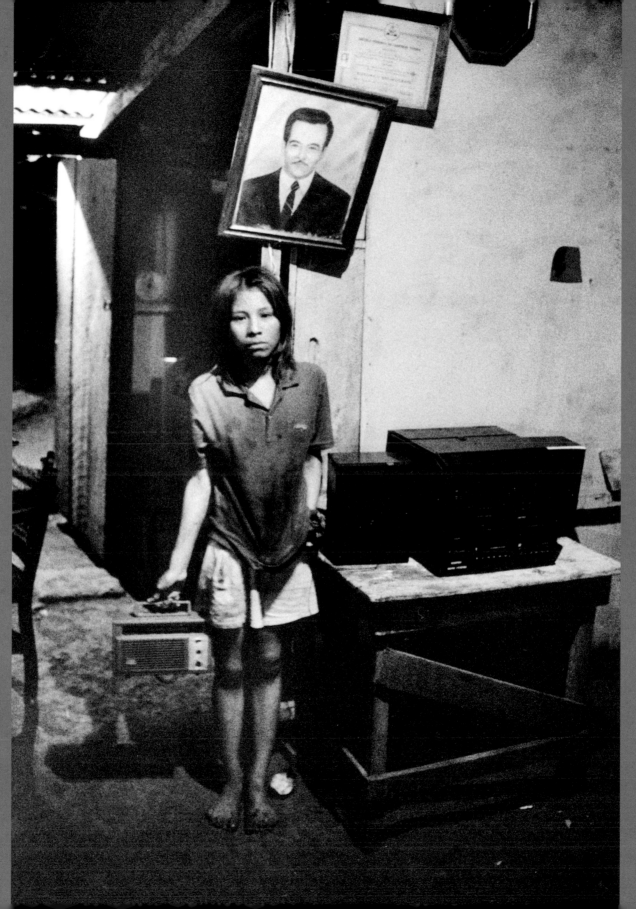

Jury (12)

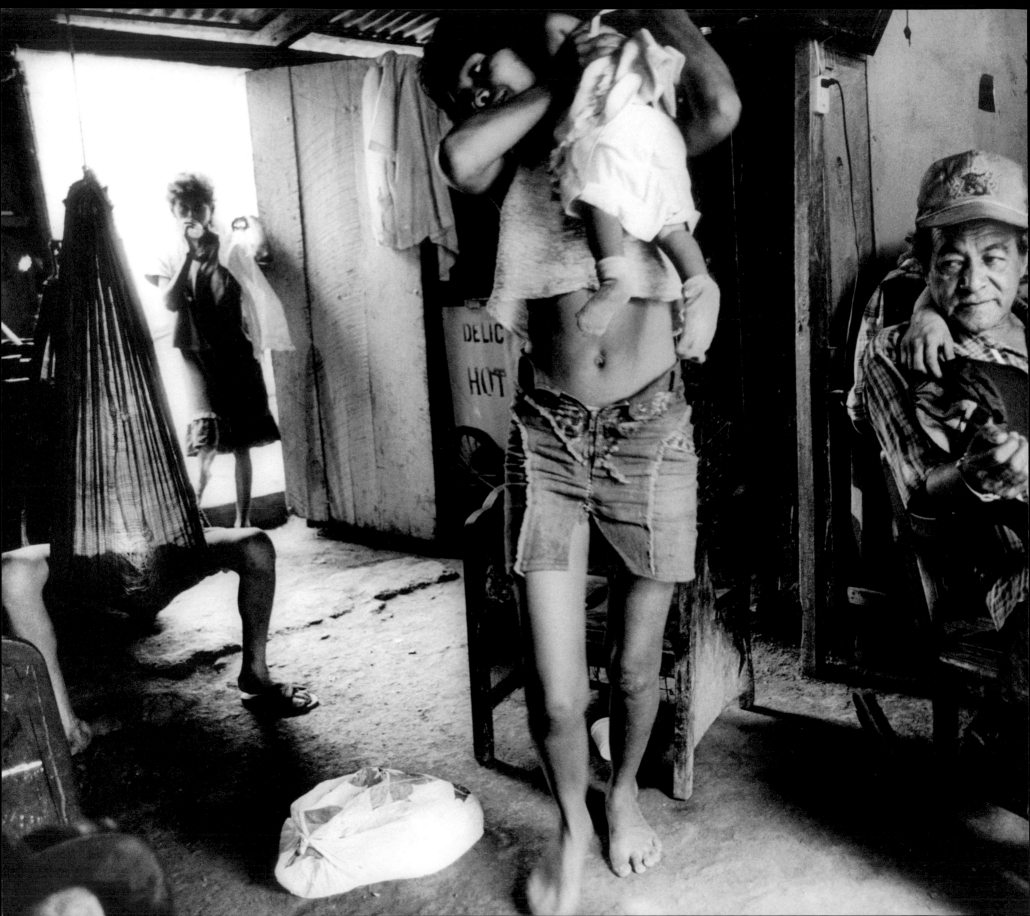

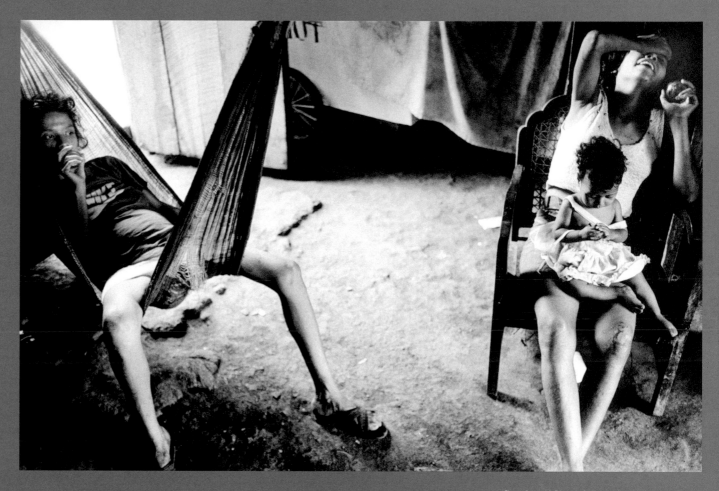

Sandra (19) and Angela (16)

Sandra (19), María (15), Angela (16),
Don Pedro, and Jury (12) at Don Pedro's house

39

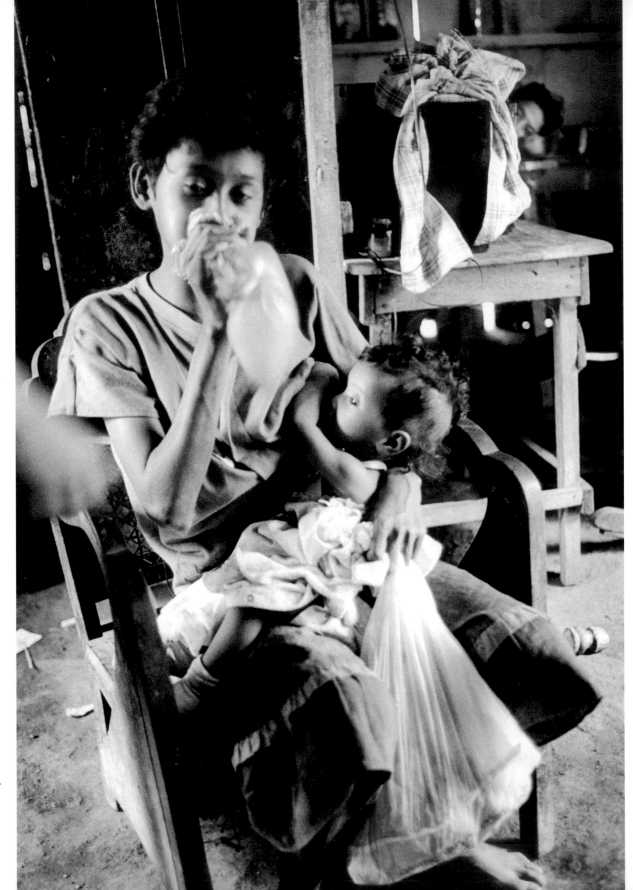

María (15) with her
one-year-old daughter

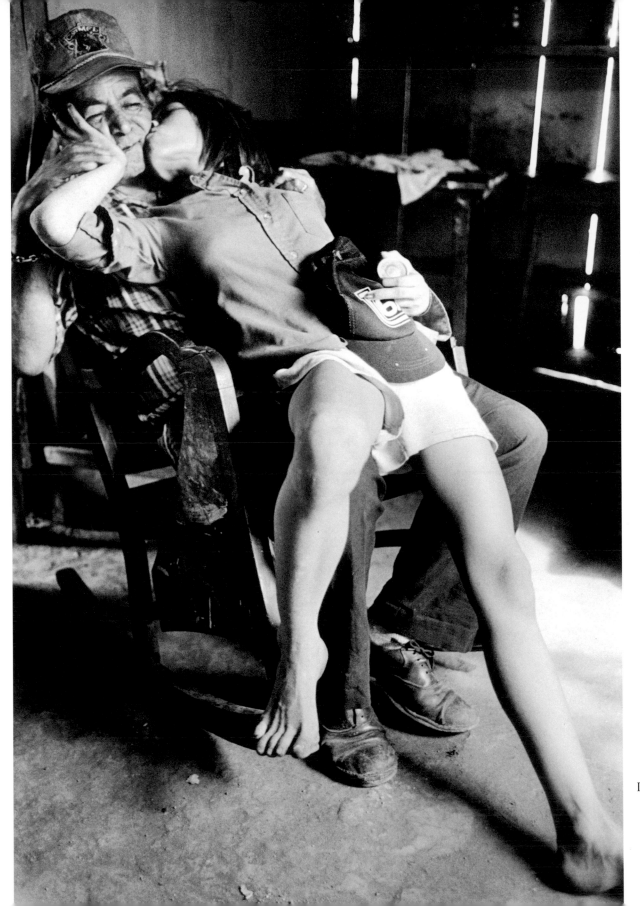

Don Pedro and Jury (12)

41

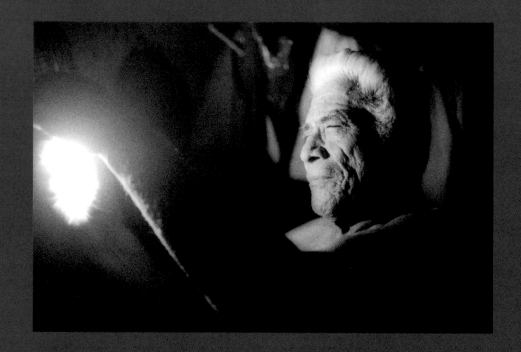

Don Cano's House

Don Cano lives inside the market. Over the years, his house has been María Coco's favorite place.
Ysenia started her street life in his house as well.

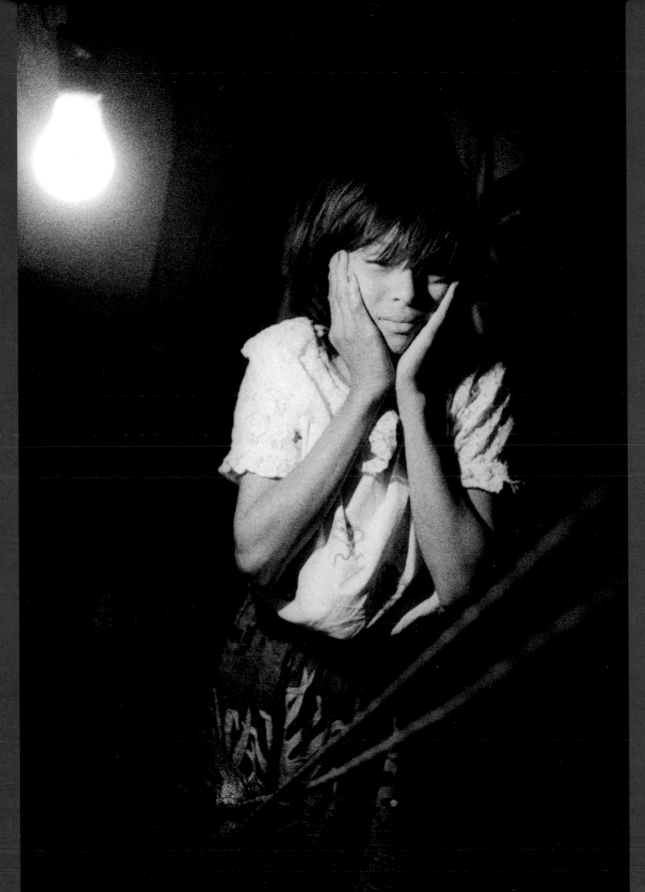

Ysenia (12)

43

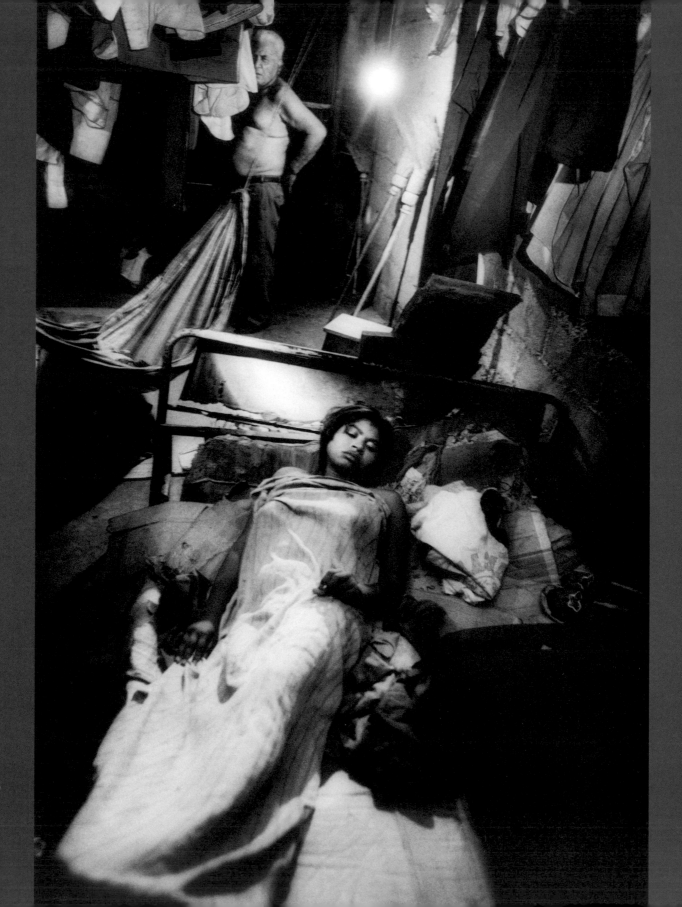

María Coco (15)

44

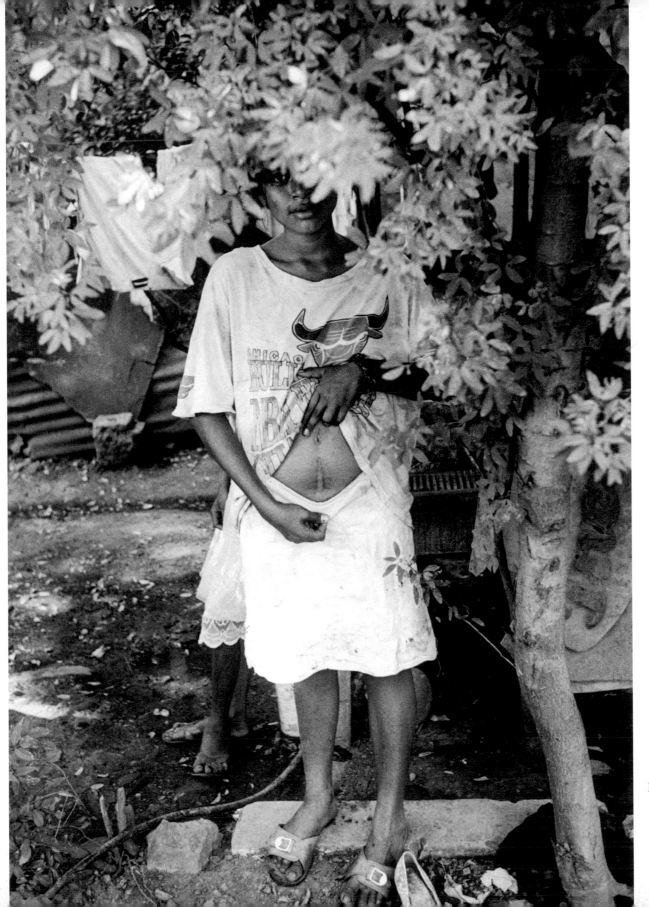

María Coco (17)

45

Previous pages: Poster in
a beauty salon, Managua
Right: Callejón de la Muerte

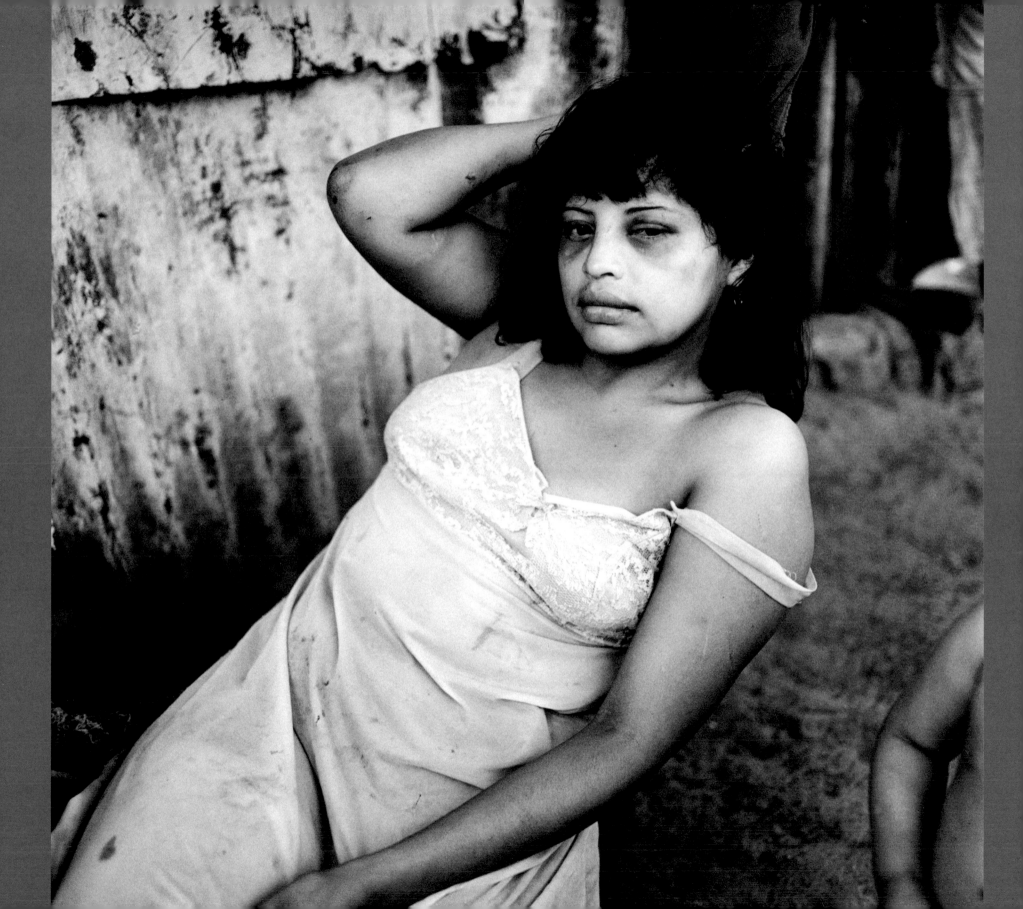

María Mercedes (16)

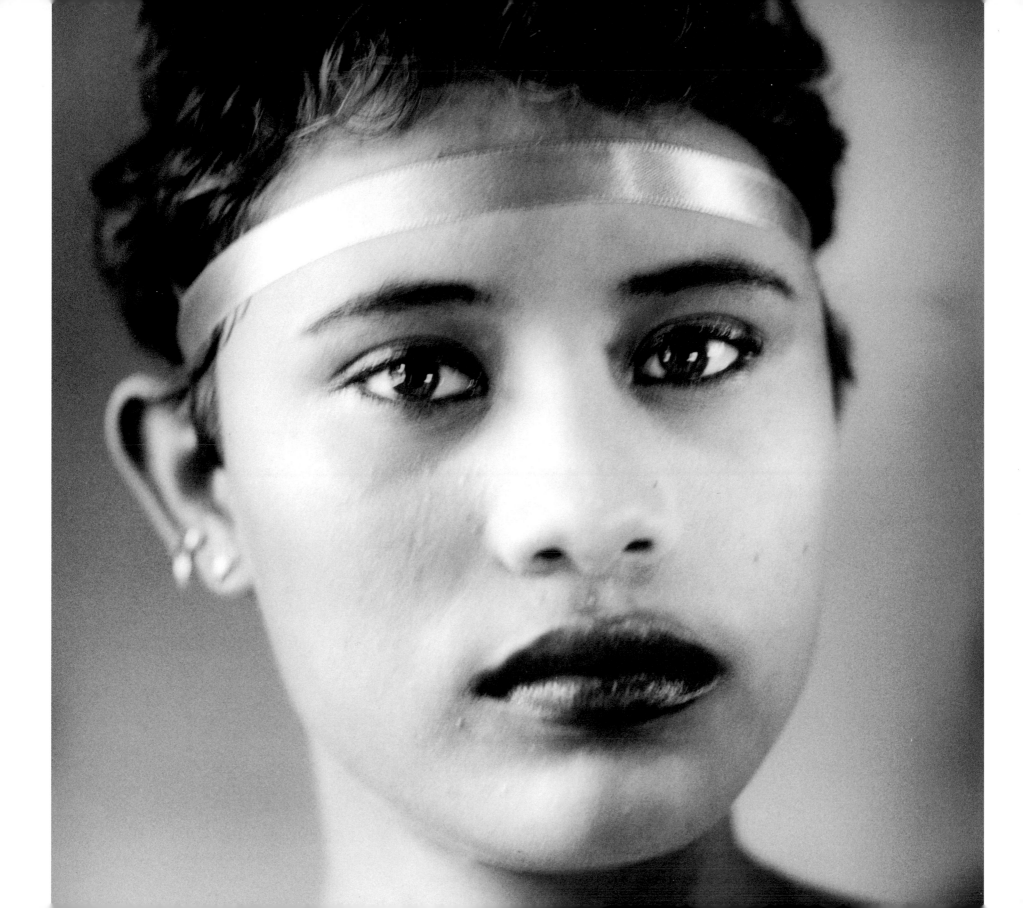

Mariana (15)

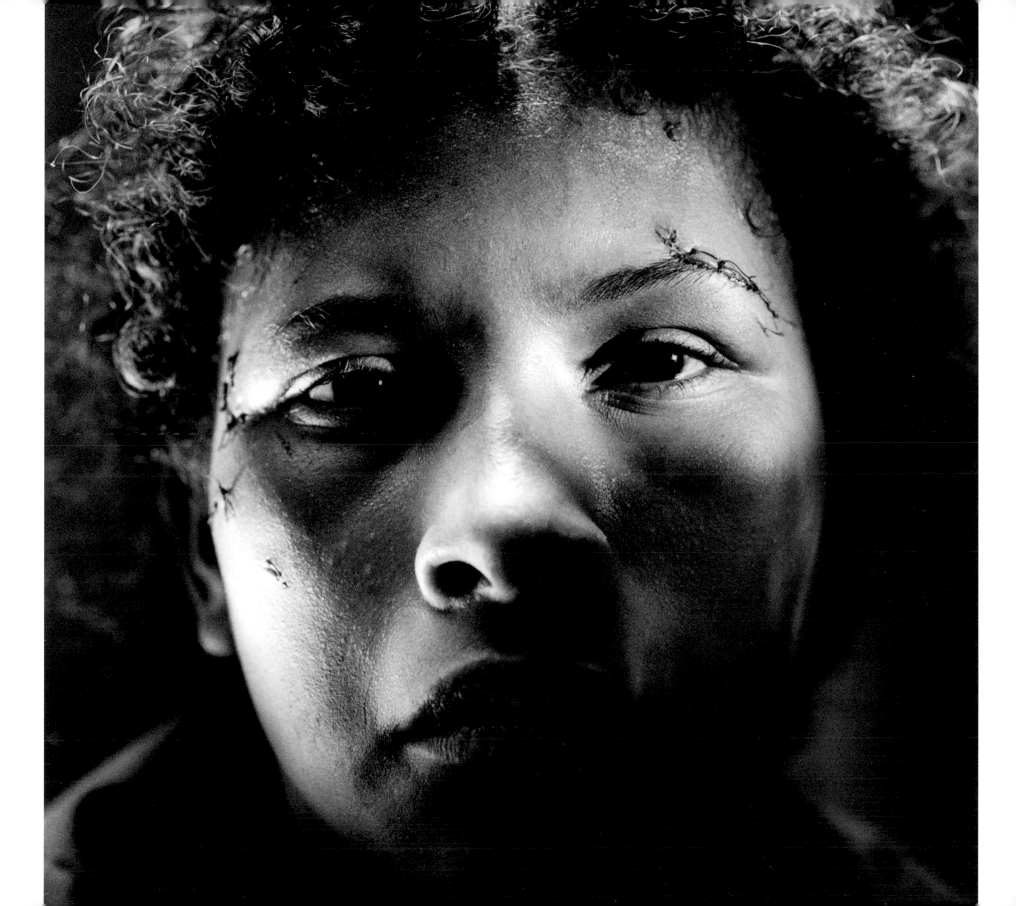

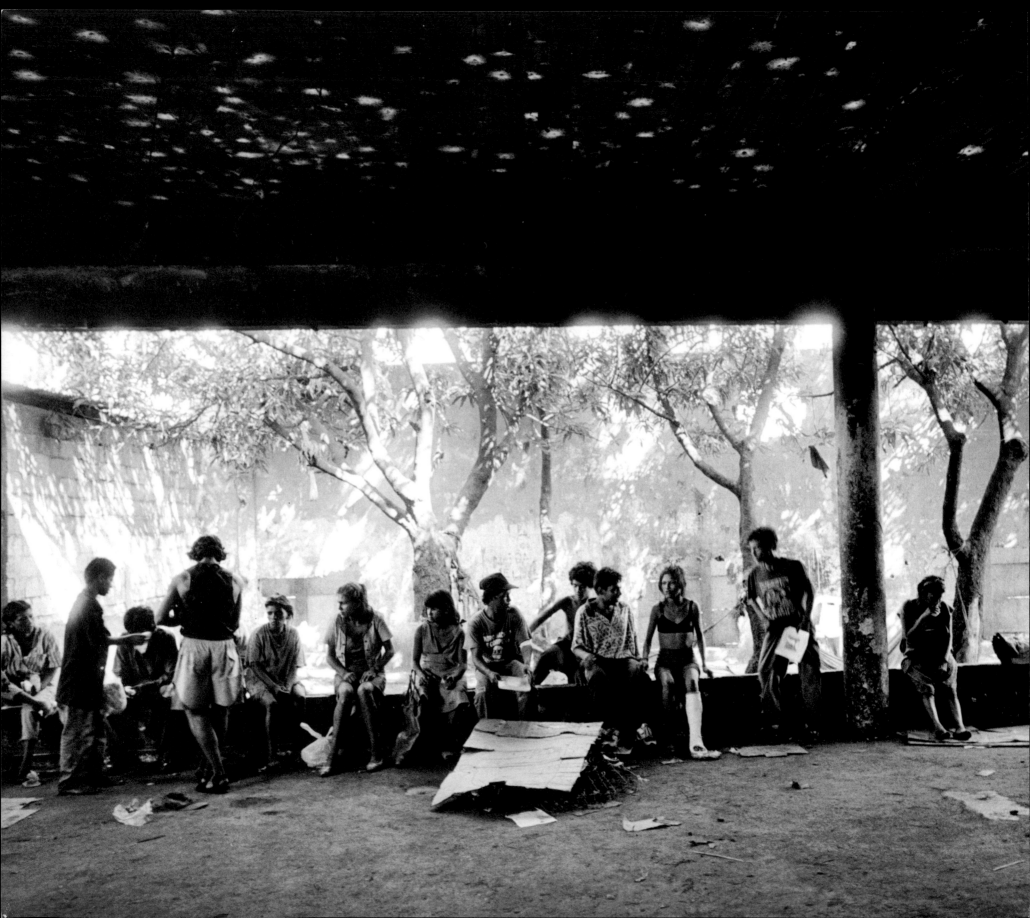

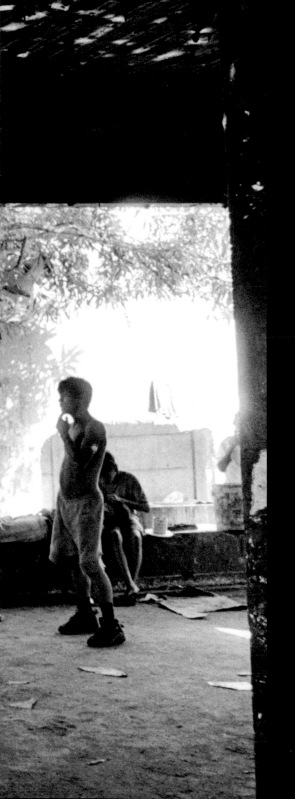

La Casita

La Casita is a ruin located in the center of the market.
Despite the fact that they may be socially harassed, assaulted, or otherwise hurt, all of the homeless kids converge here and many use it as a nighttime shelter.

Left: Full house at La Casita
Right: Boy with his bed in a tree

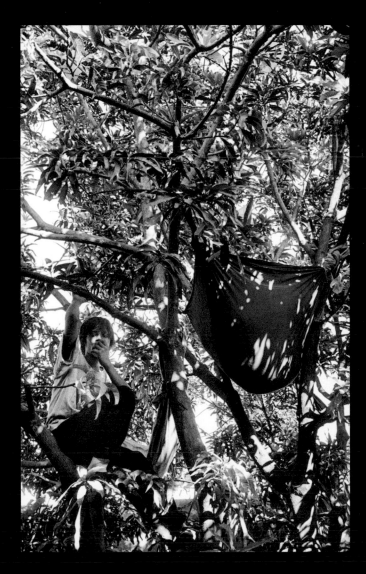

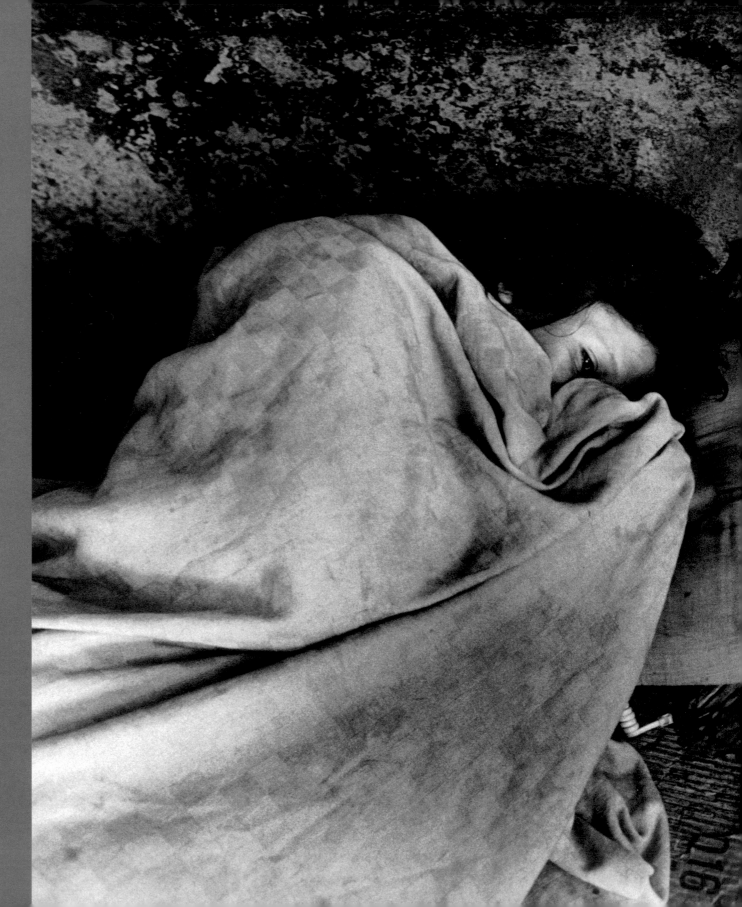

María Teresa (16) sleeps
in La Casita.

56

58 Near La Casita, people dwell among ruins.

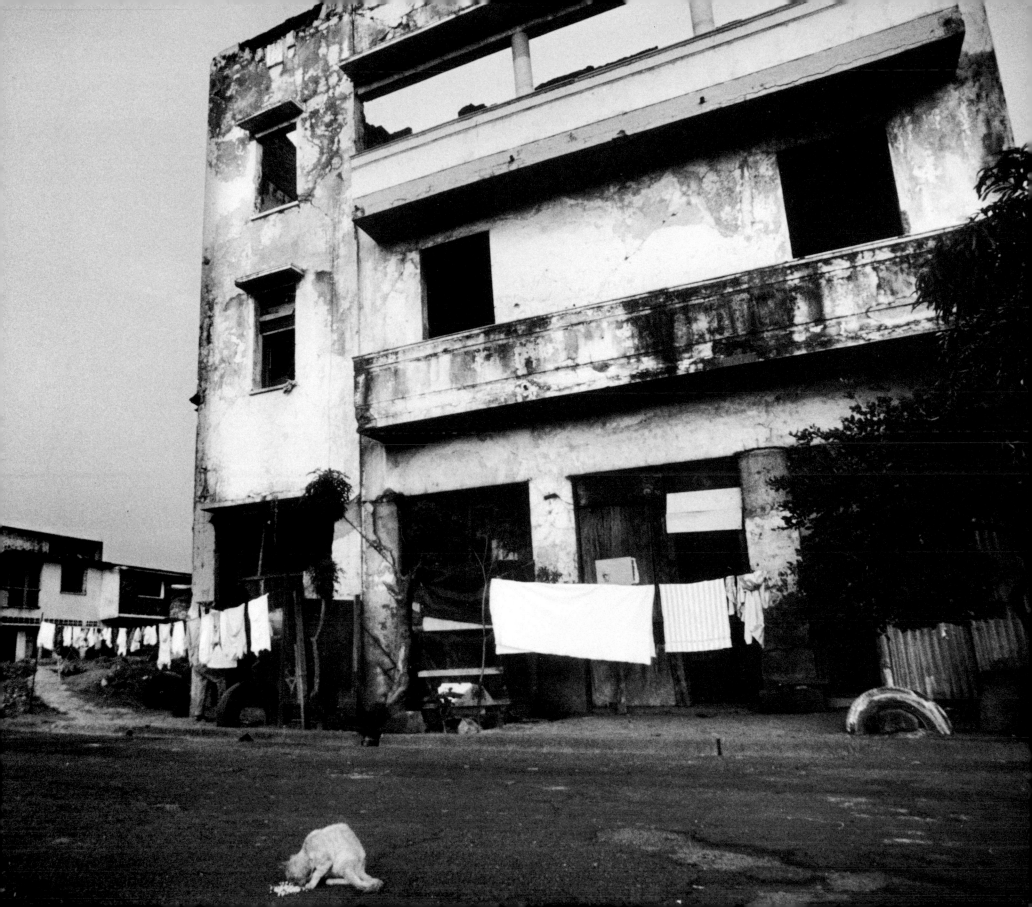

Right: Callejón de la Muerte
Following pages: Assaulted in Callejón de la Muerte

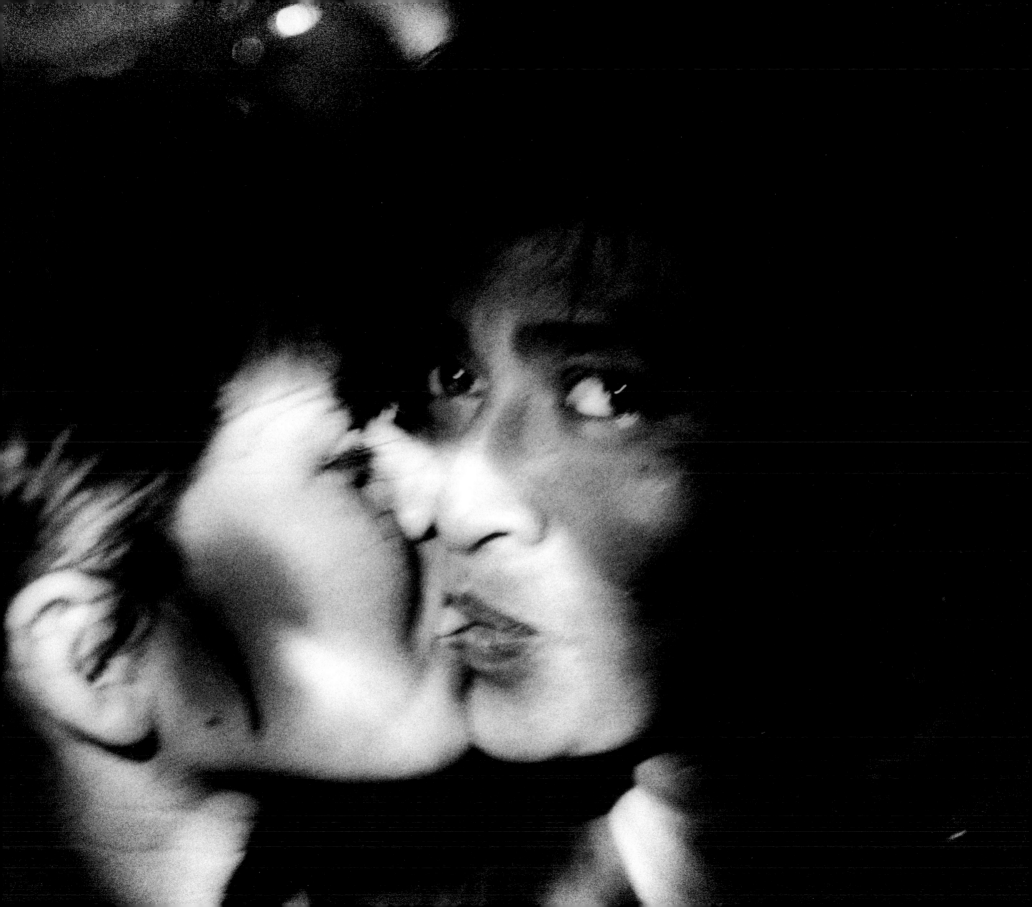

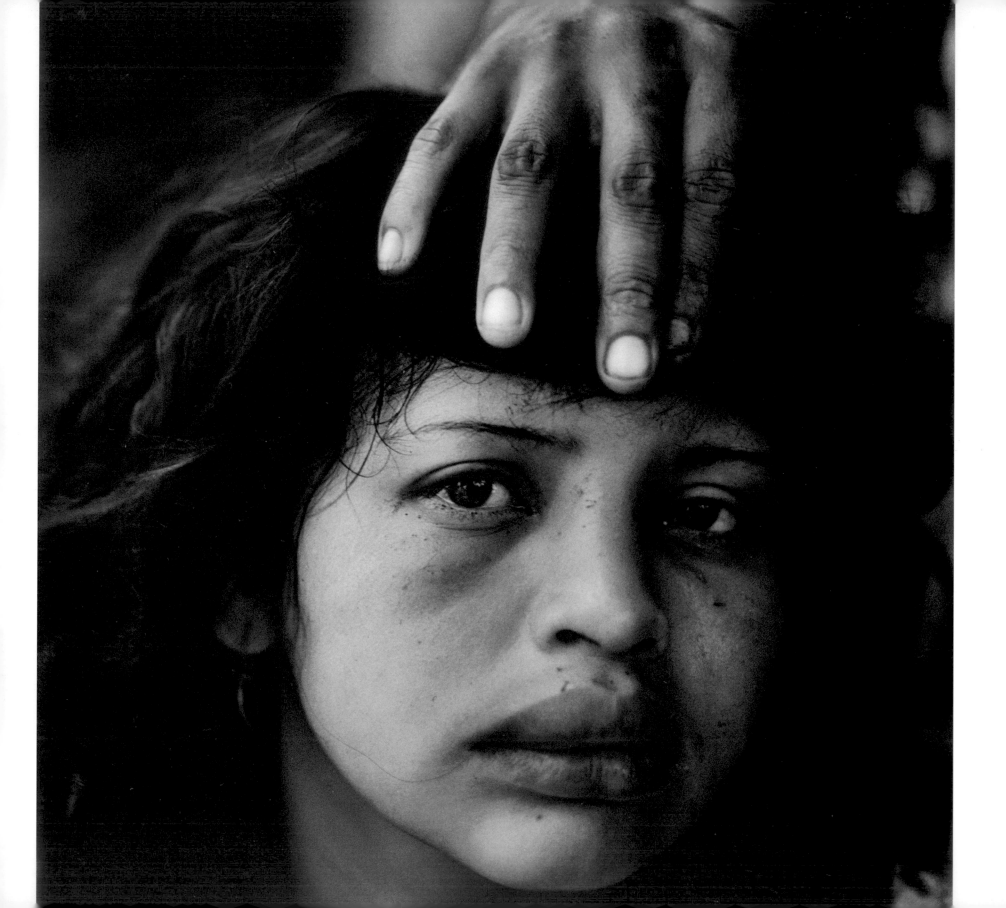

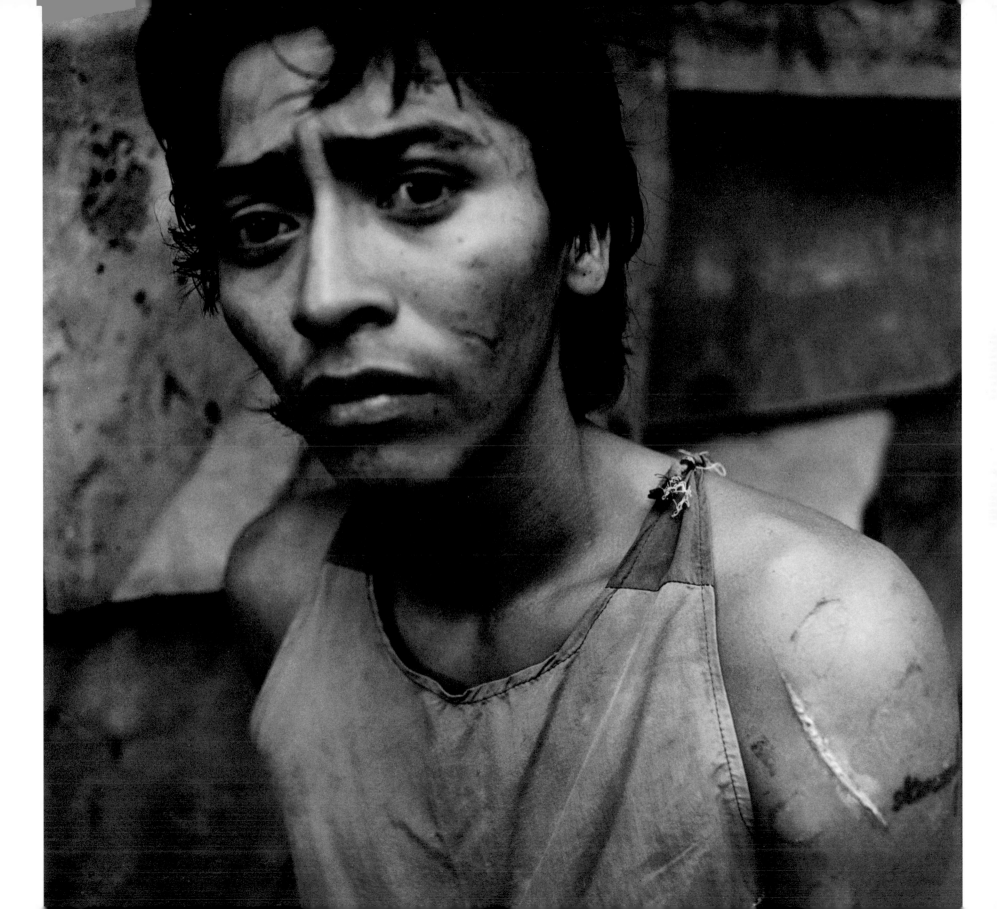

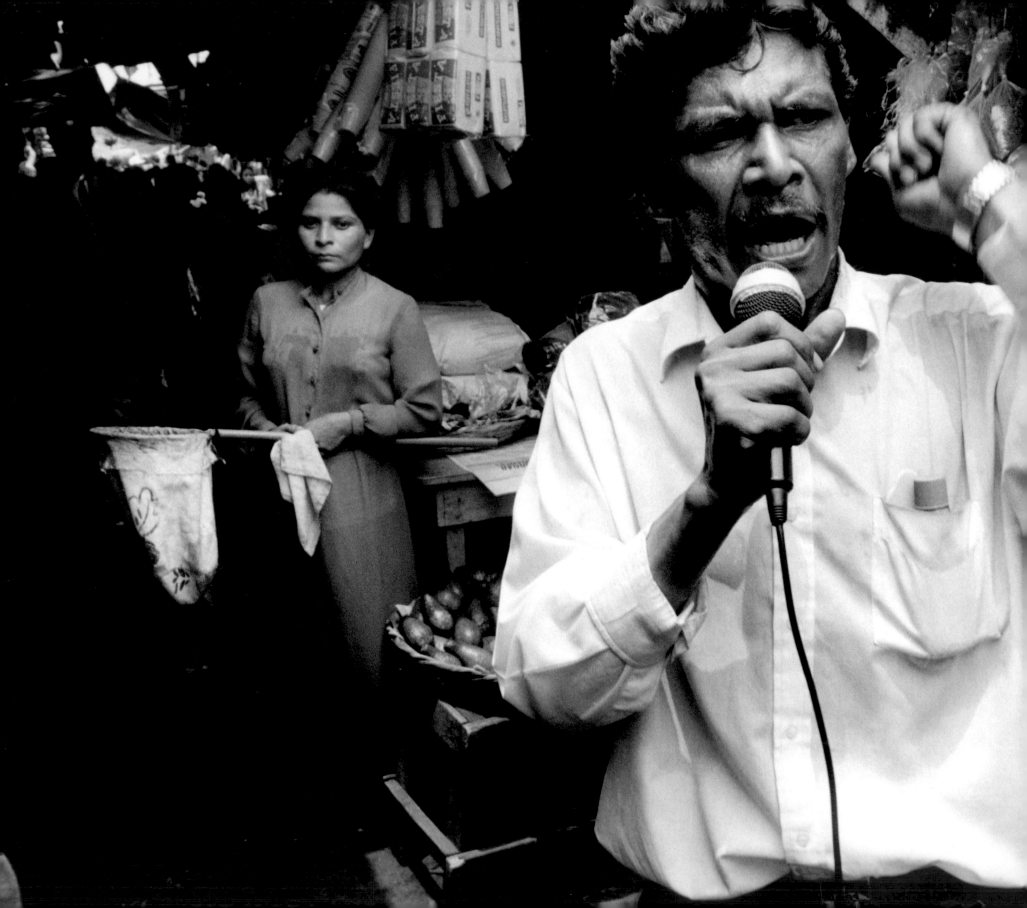

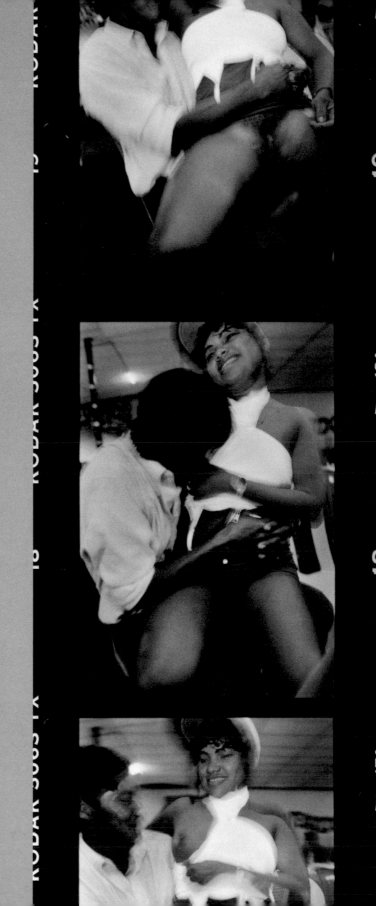

Previous pages:
Mercado Oriental

Left: Revivalist at
Mercado Oriental

Right: Polanco Nightclub

67

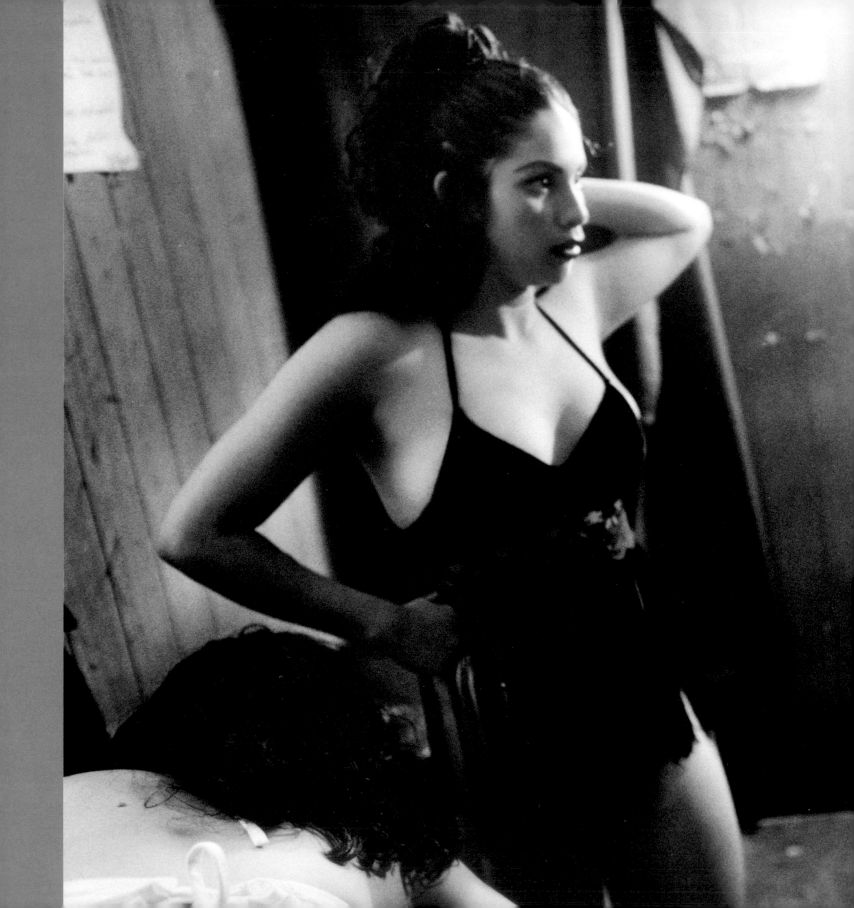

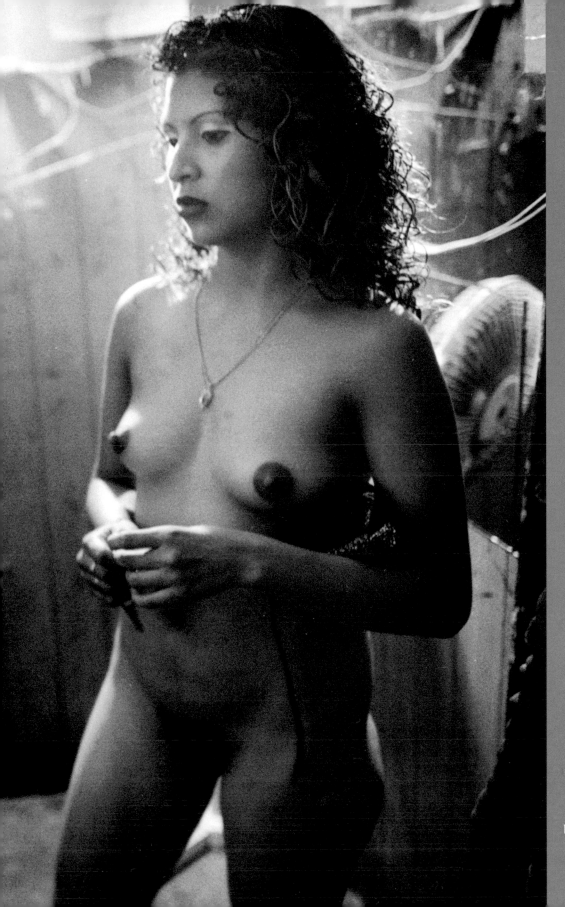

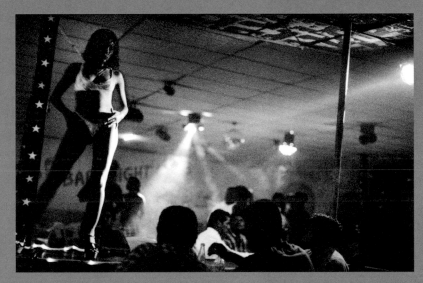

Darling onstage at Polanco

Darling backstage at Polanco

69

70 Darling taking the Sacrament

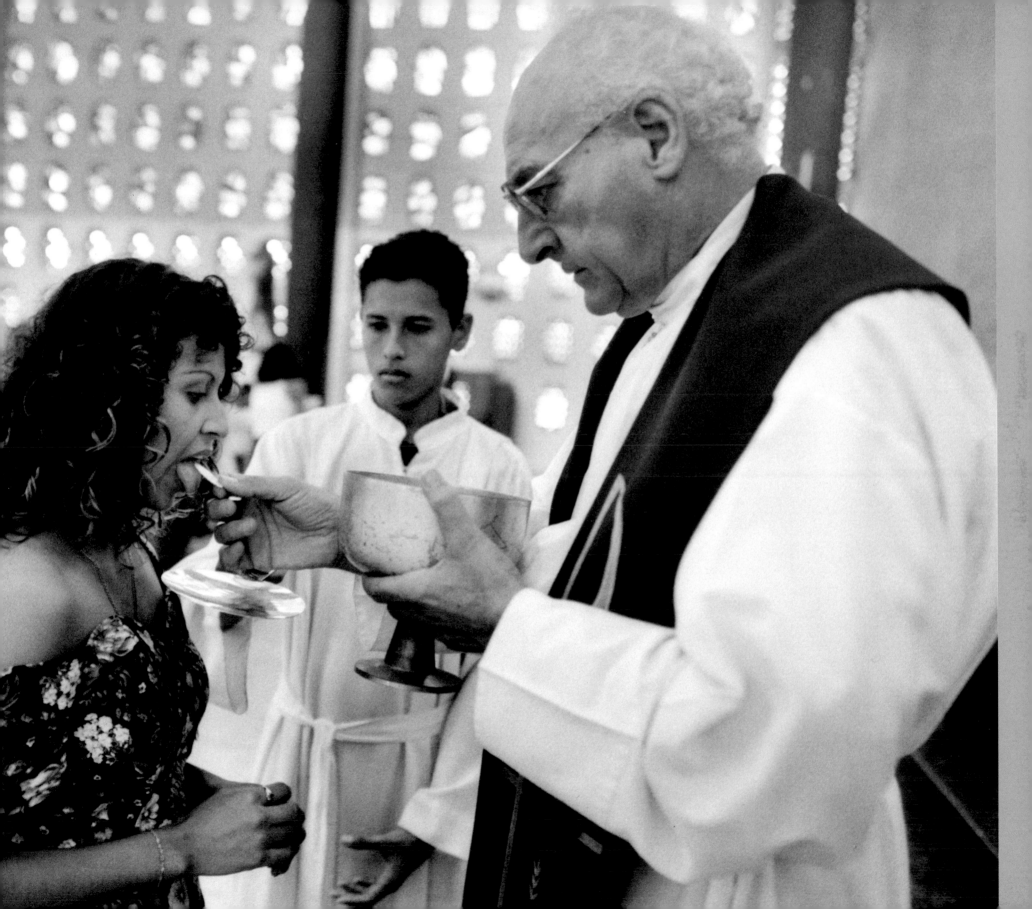

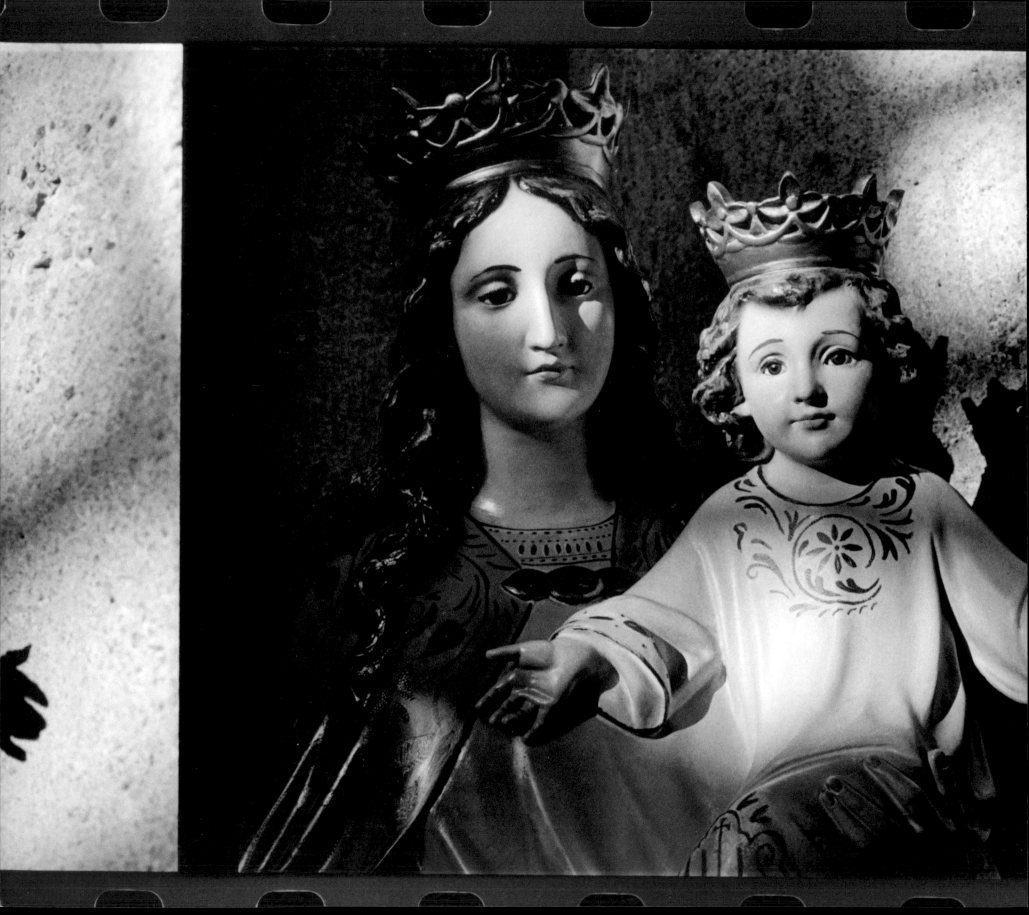

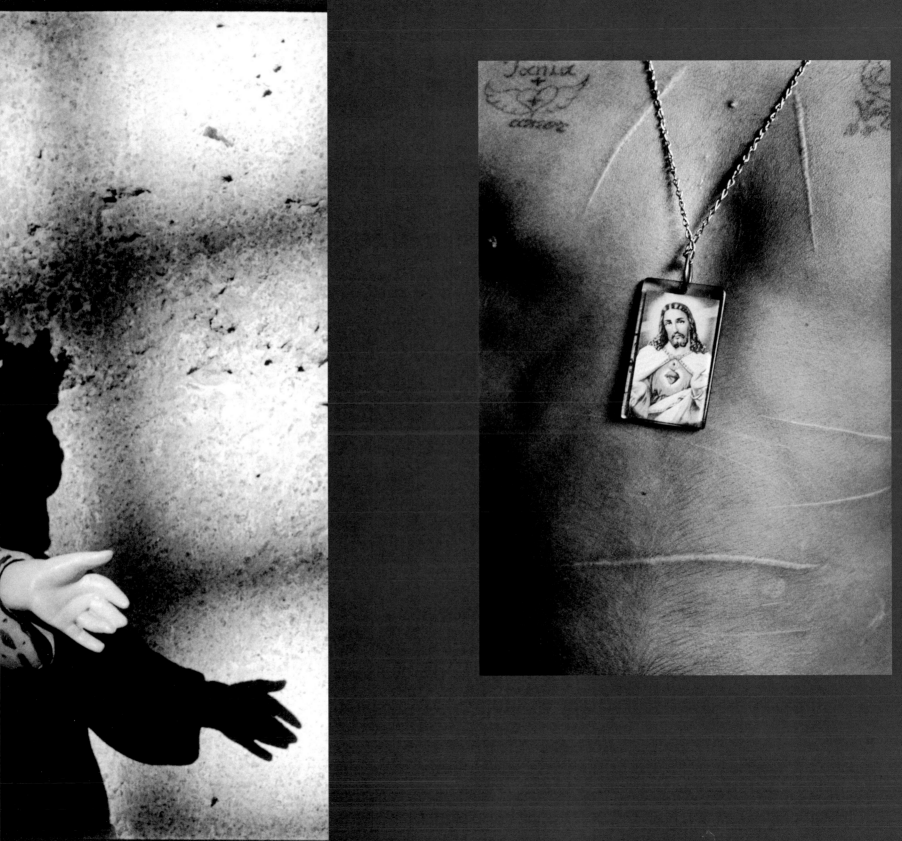

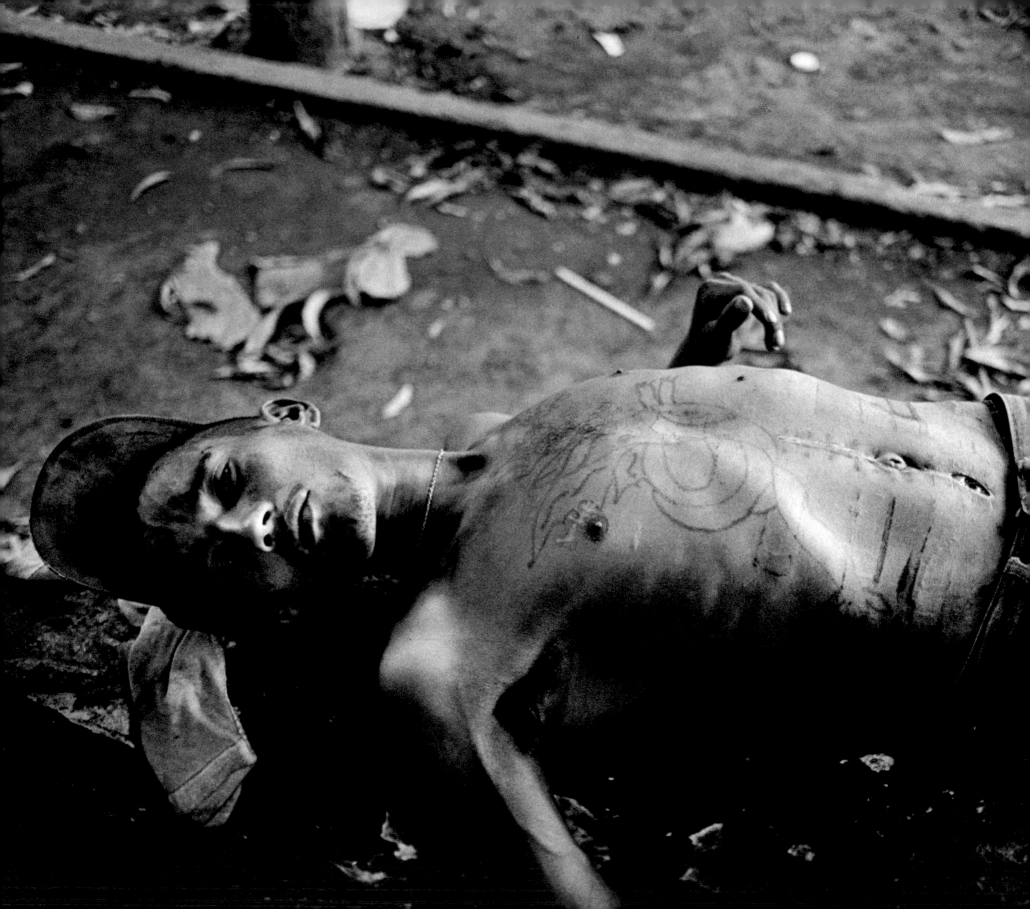

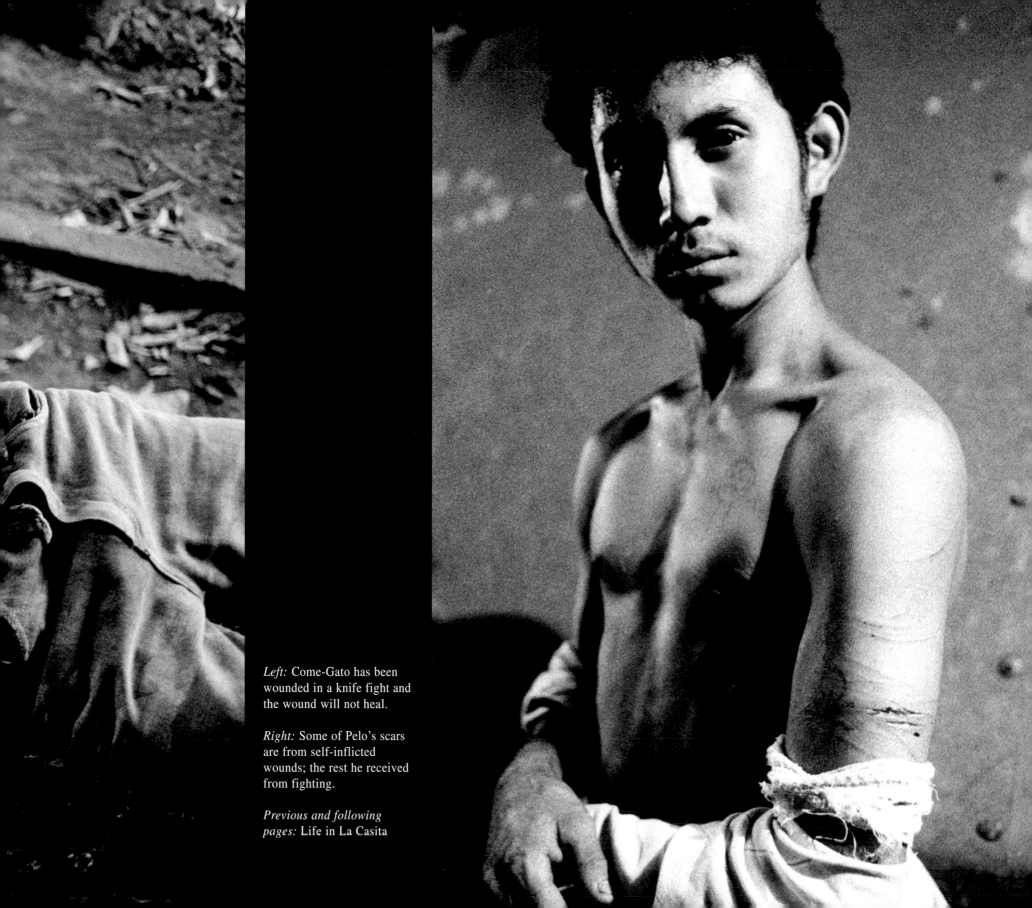

Left: Come-Gato has been wounded in a knife fight and the wound will not heal.

Right: Some of Pelo's scars are from self-inflicted wounds; the rest he received from fighting.

Previous and following pages: Life in La Casita

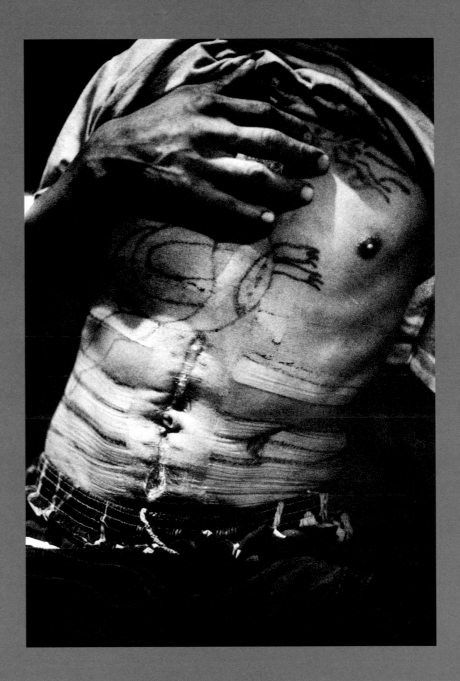

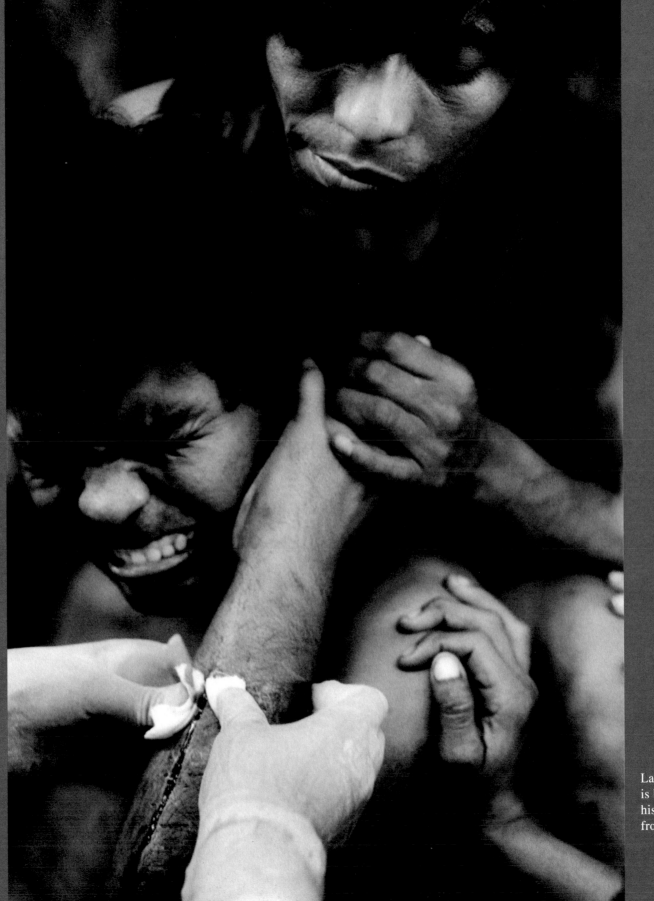

La Casita—Agustín's wound
is badly infected. Pepe comforts
his friend while Maira,
from the street team, cleans it.

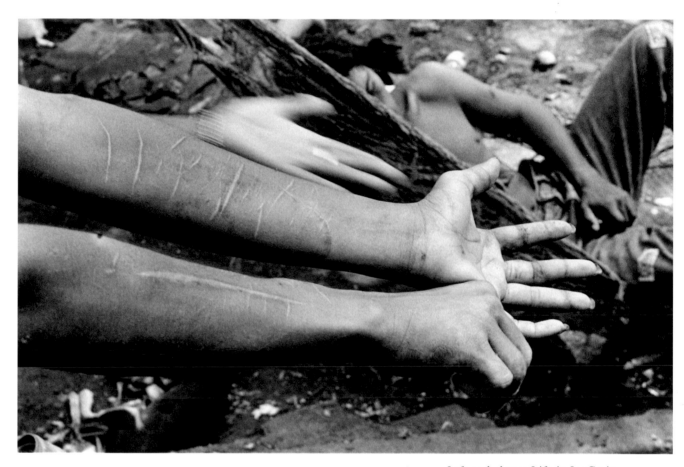

Left and above: Life in La Casita.

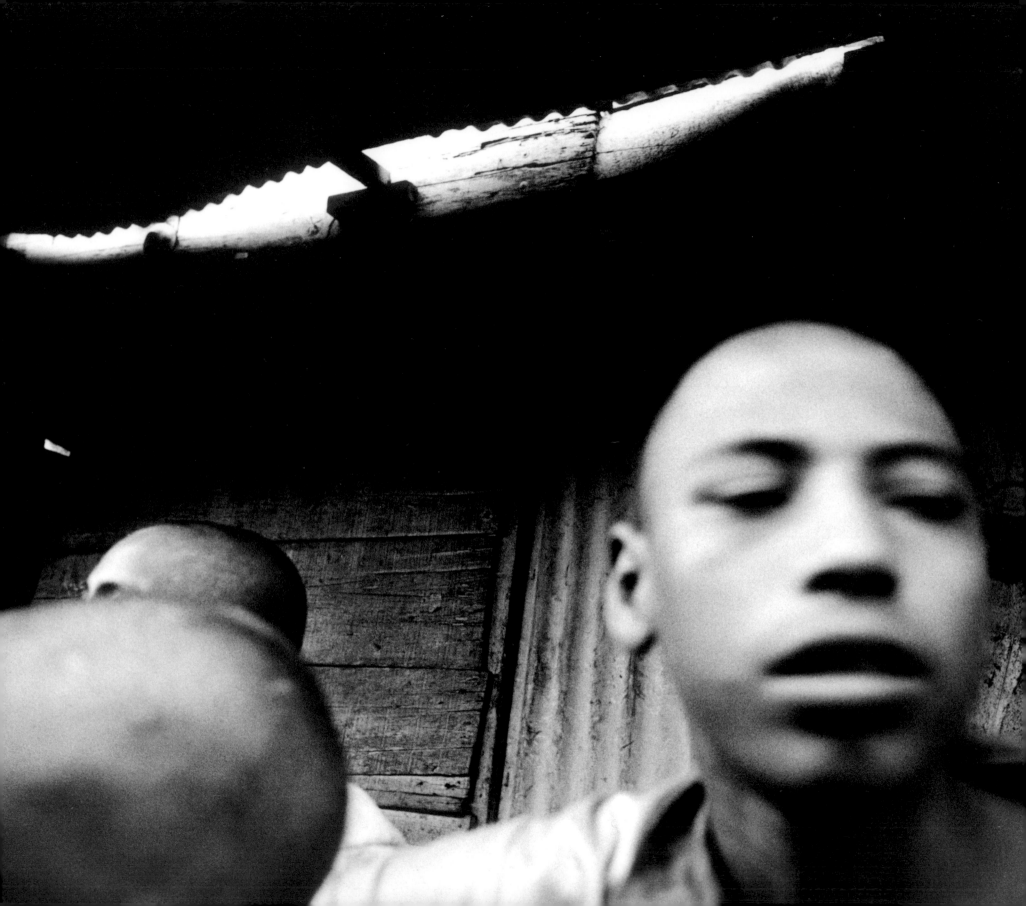

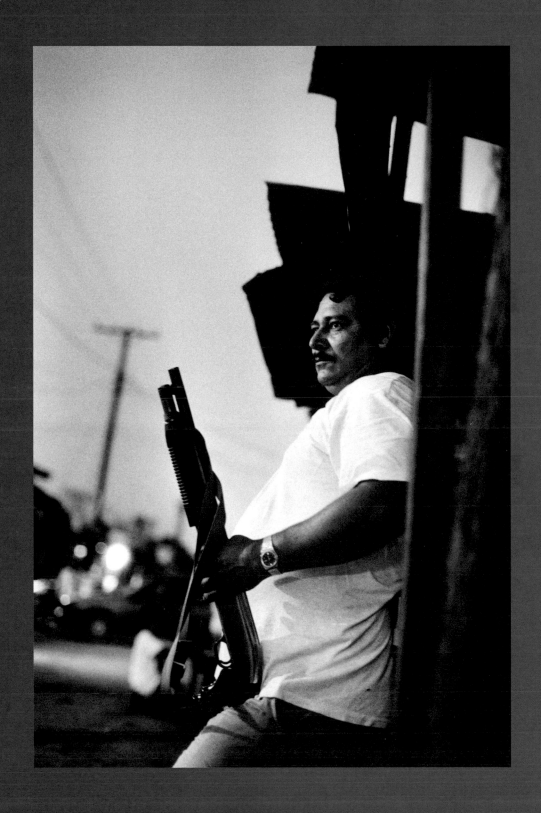

Callejón de la Muerte

Callejón de la Muerte, "Death Alley," is less than one hundred meters long. All of the shanties in the alley are used as cabins for prostitution. The whole alley is a brothel run by La Chila. The prostitutes tolerate the street kids who hang around the alley.

Previous pages: Callejón de la Muerte
Pages 84–91: Prostitutes in their cabins at Callejón de la Muerte

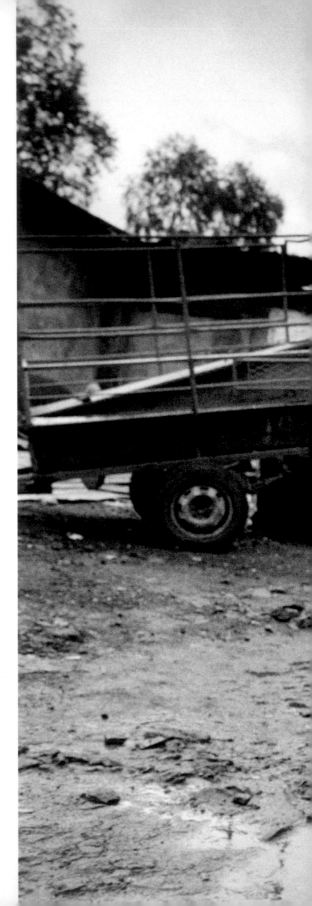

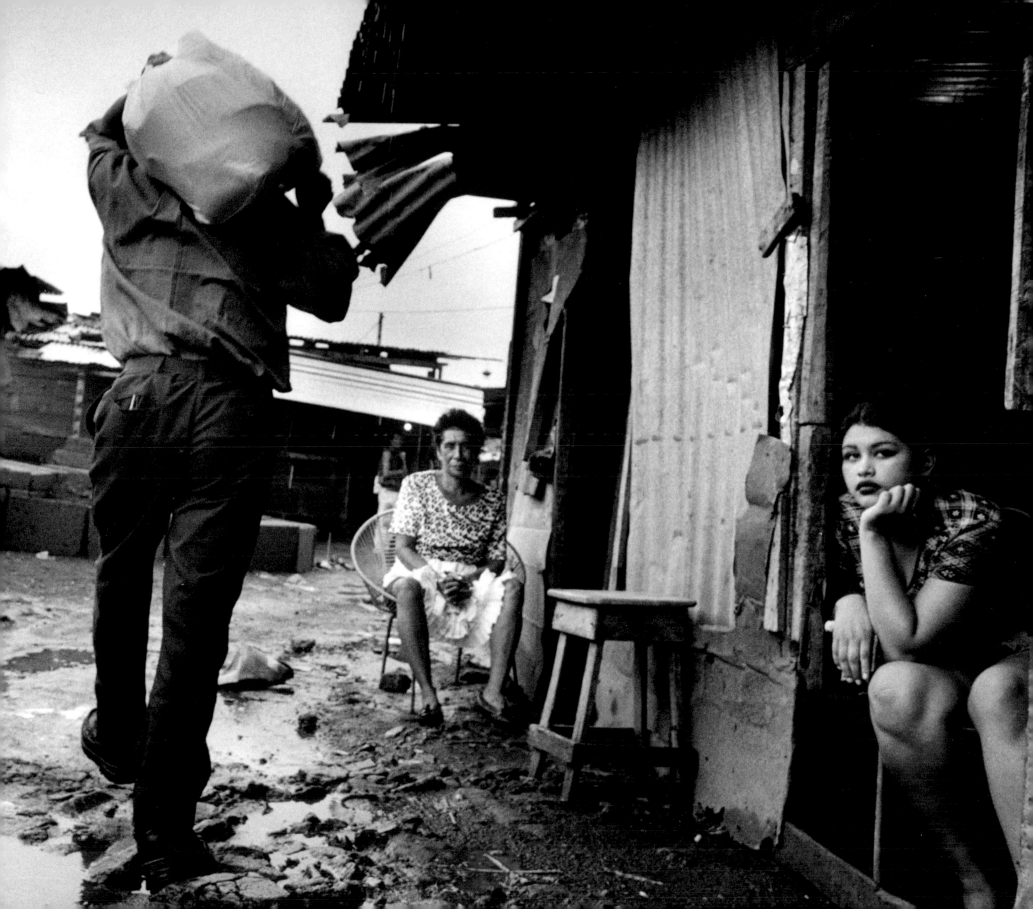

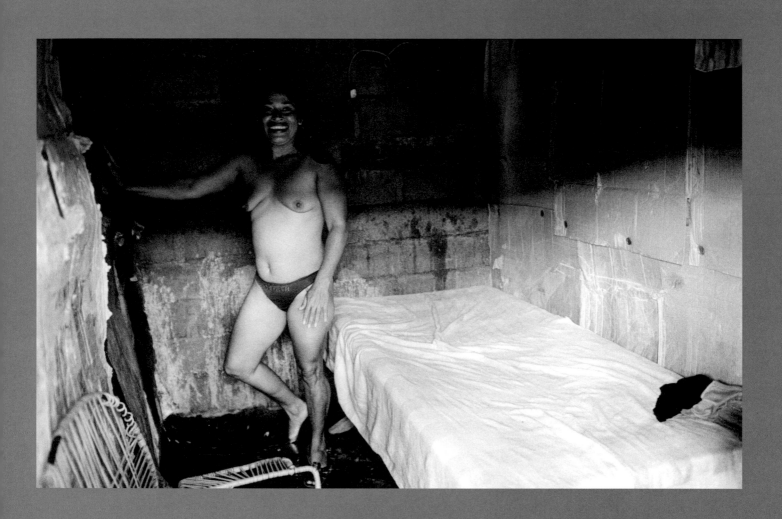

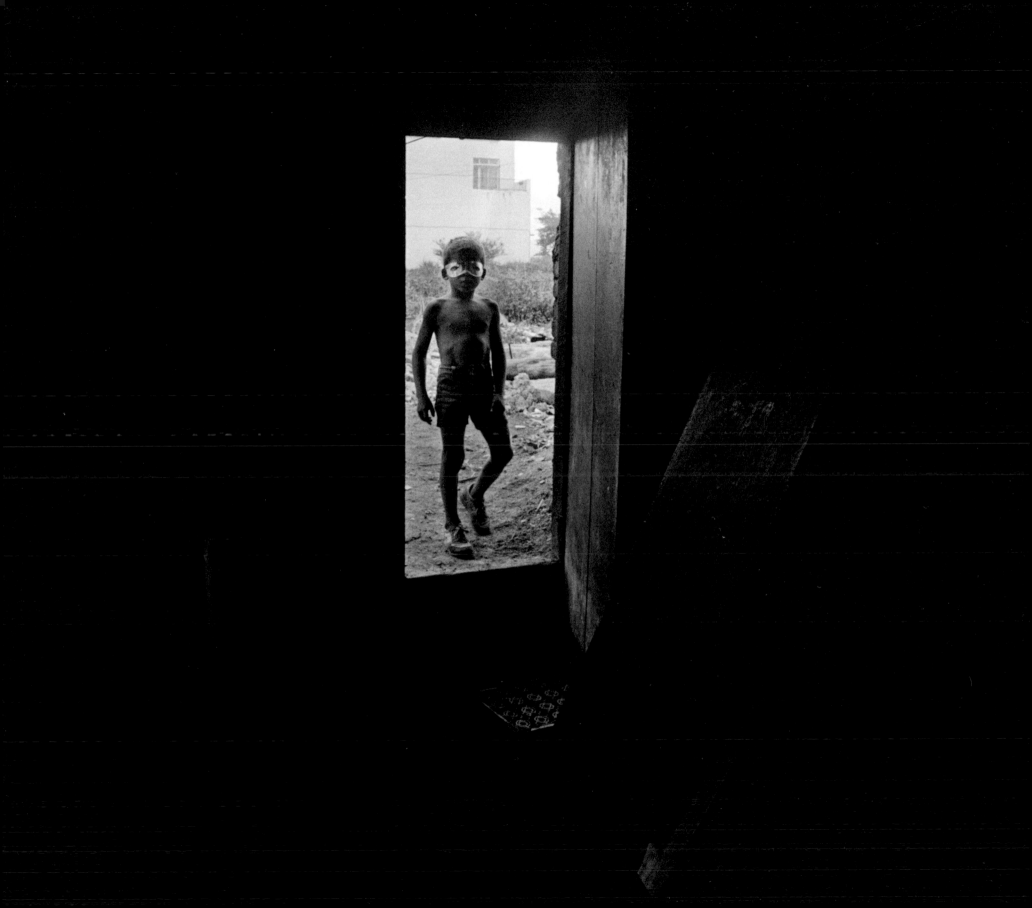

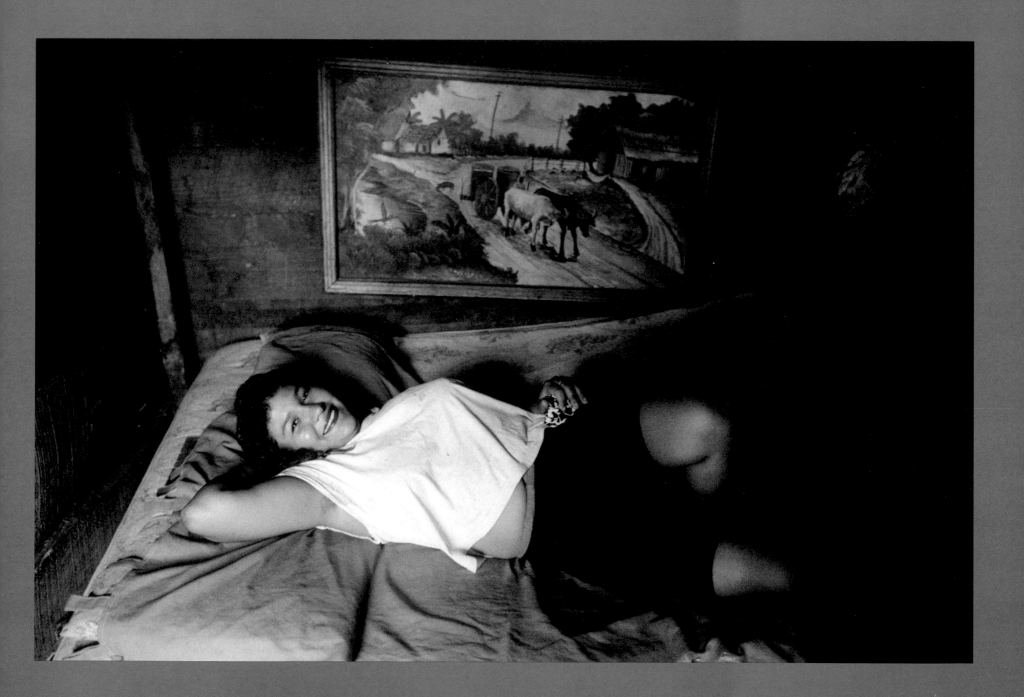

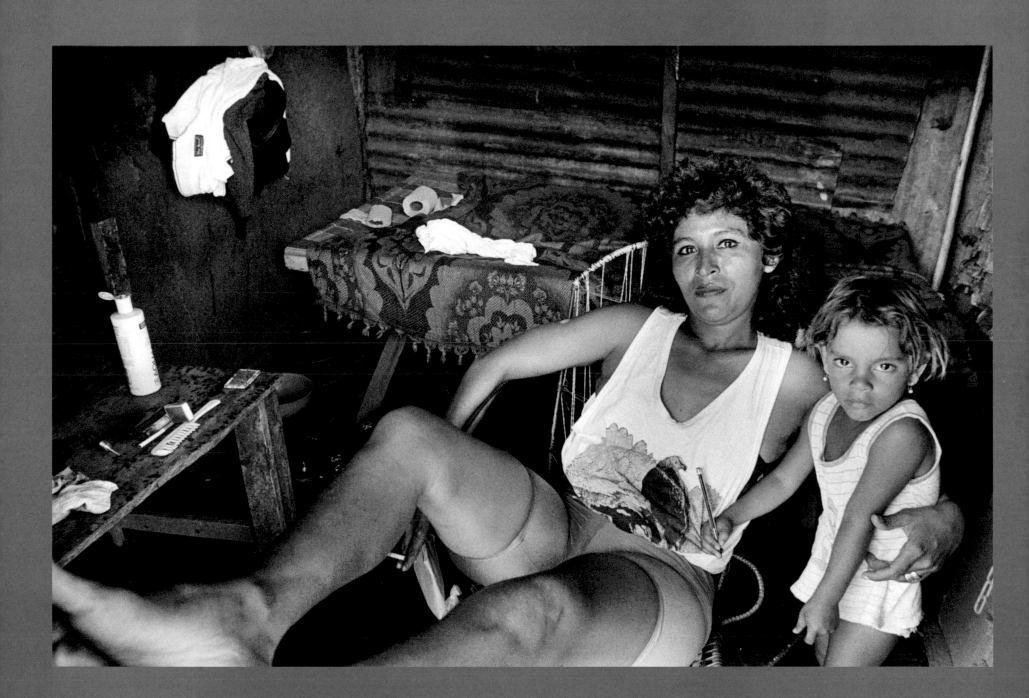

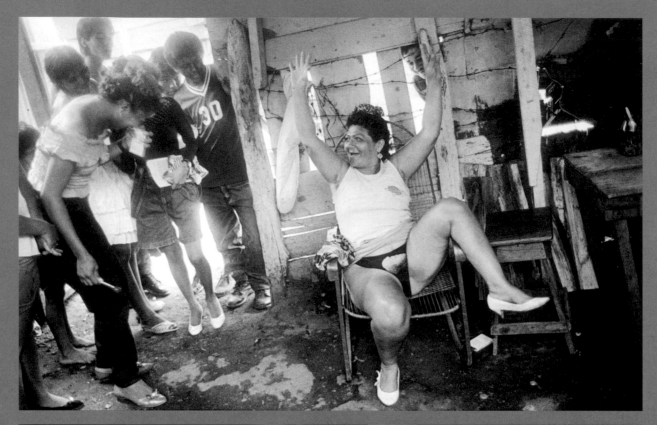

Doña Chila, 1995

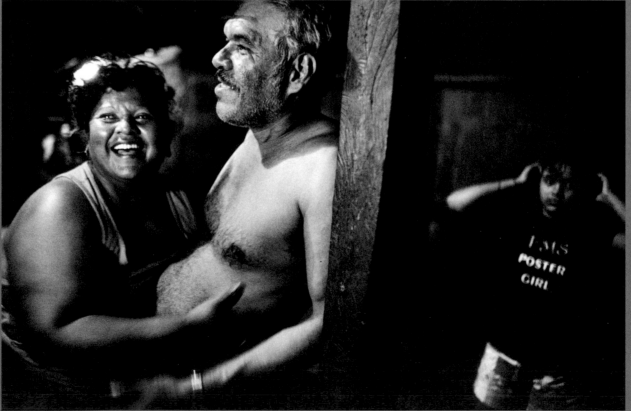

Doña Chila, 1999

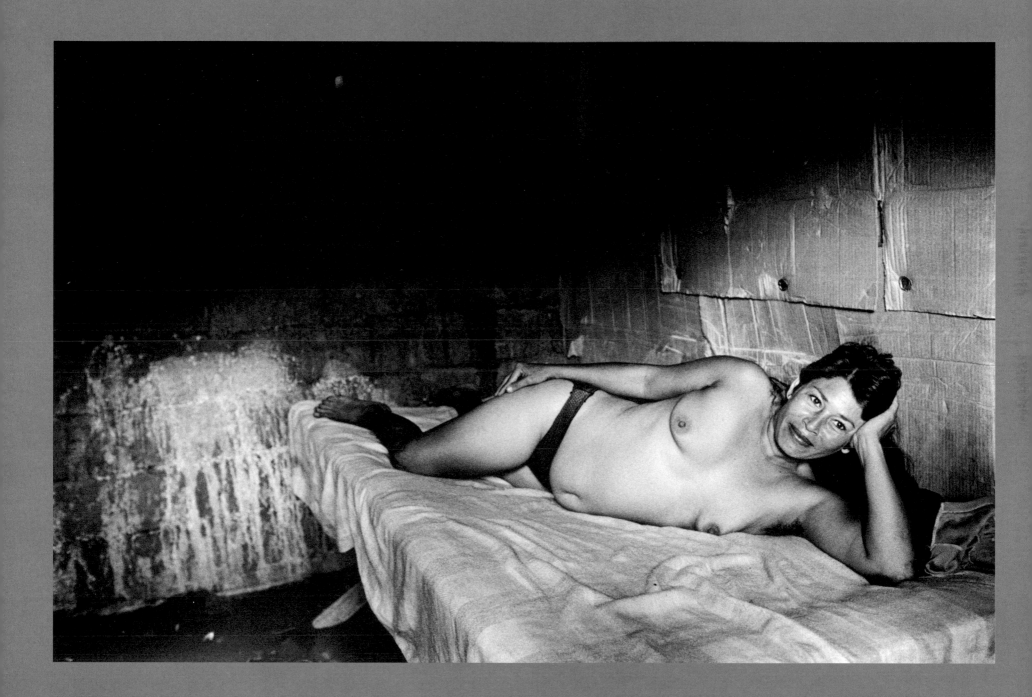

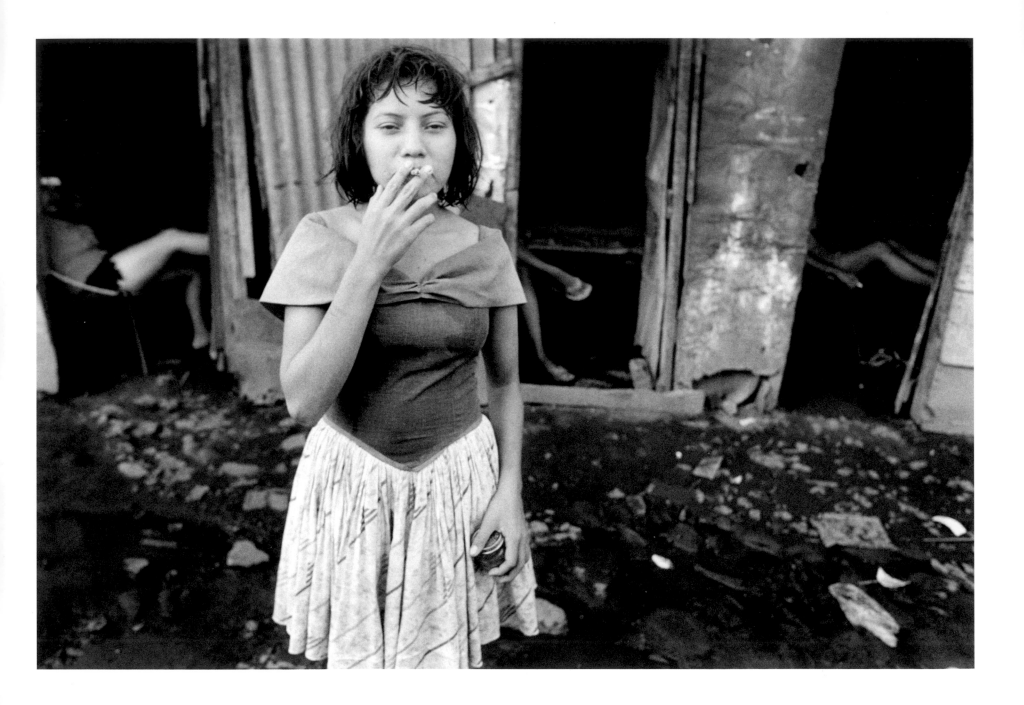

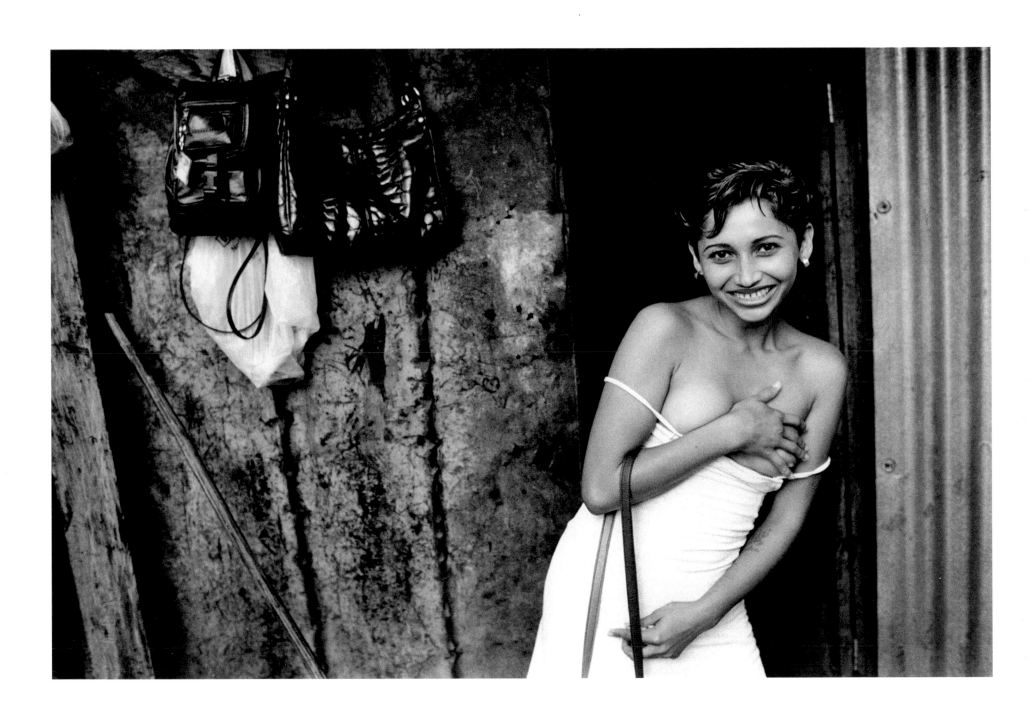

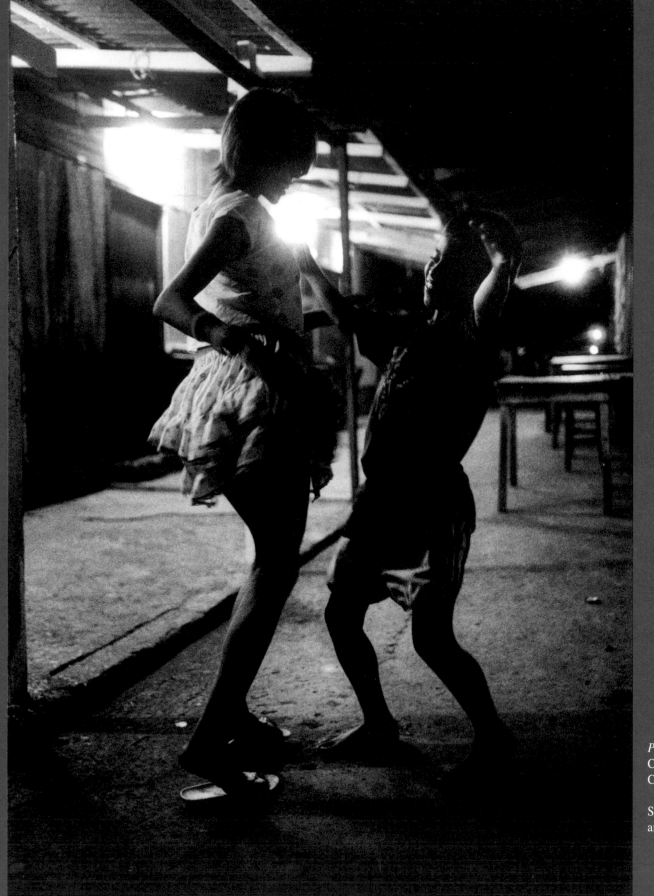

94

Previous pages:
Children rehearse adult roles at
Callejón de la Muerte.

Sonia Mercedes (14)
and Carlito (12)

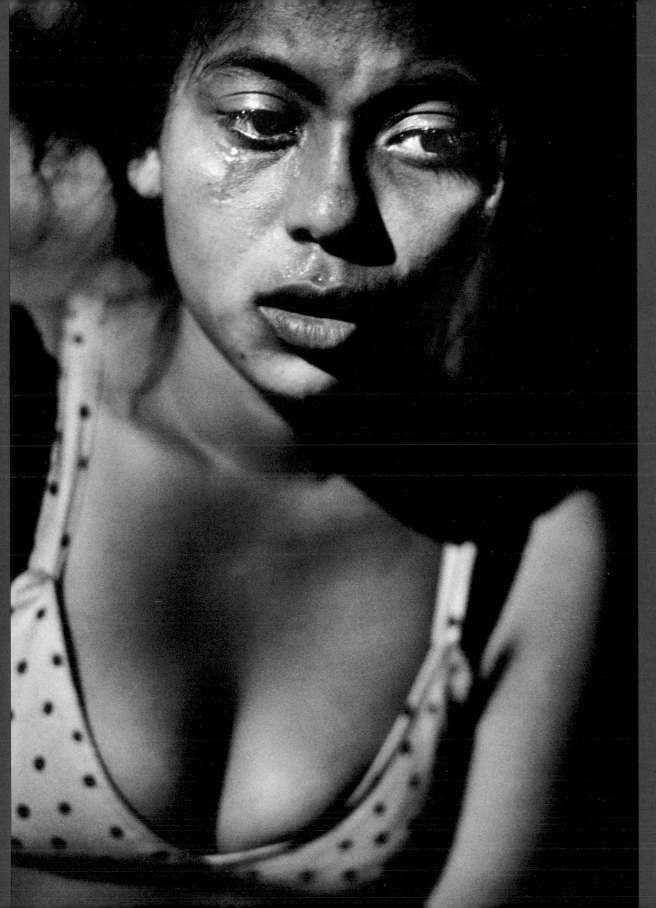

A newcomer to
Callejón de la Muerte

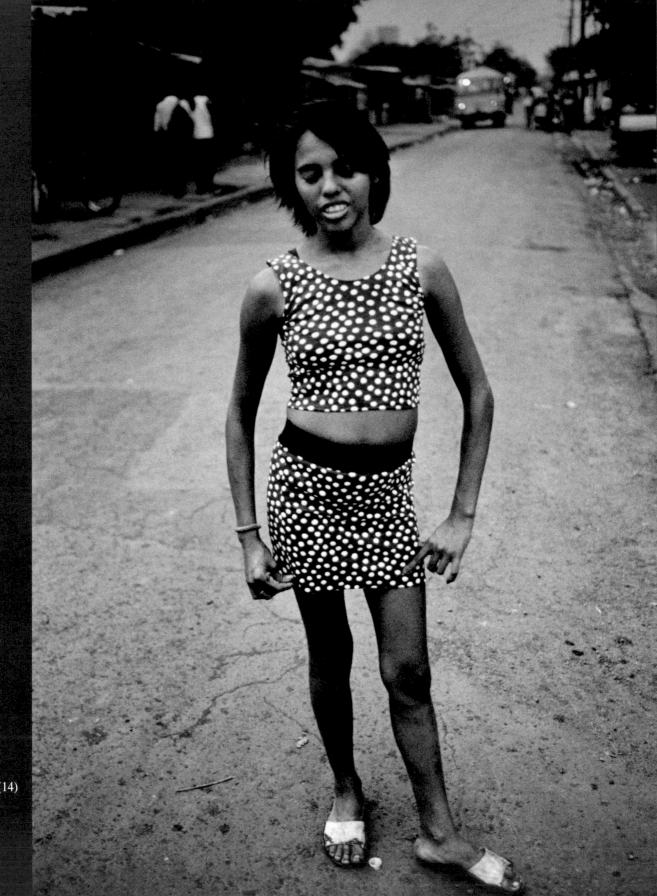

Sonia Mercedes (14)

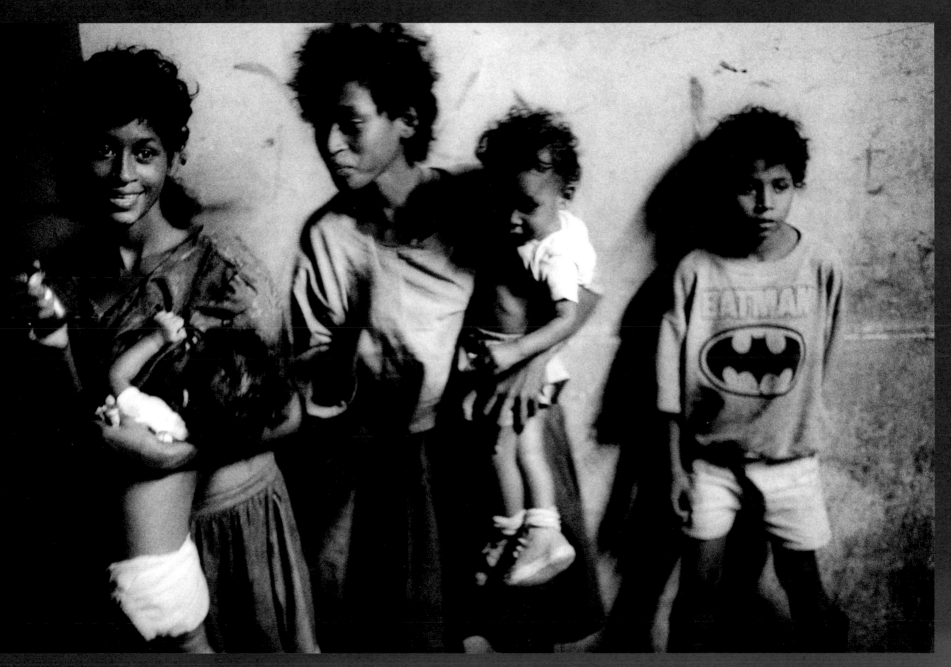

María (15) and Carolina (15) with their babies and their little brother

Responsibility

In a desperate attempt to force Carolina, age fifteen, to nurture her own child, Carolina's mother shackles her. Carolina has a twin sister, María. Both girls were impregnated by the same old man at the age of thirteen.

María and Carolina roam the Mercado Oriental at night, a glass of glue in one hand and a baby in the other. Now and then their mother resorts to chains to keep them away from all this, to make the girls take responsibility for their babies.

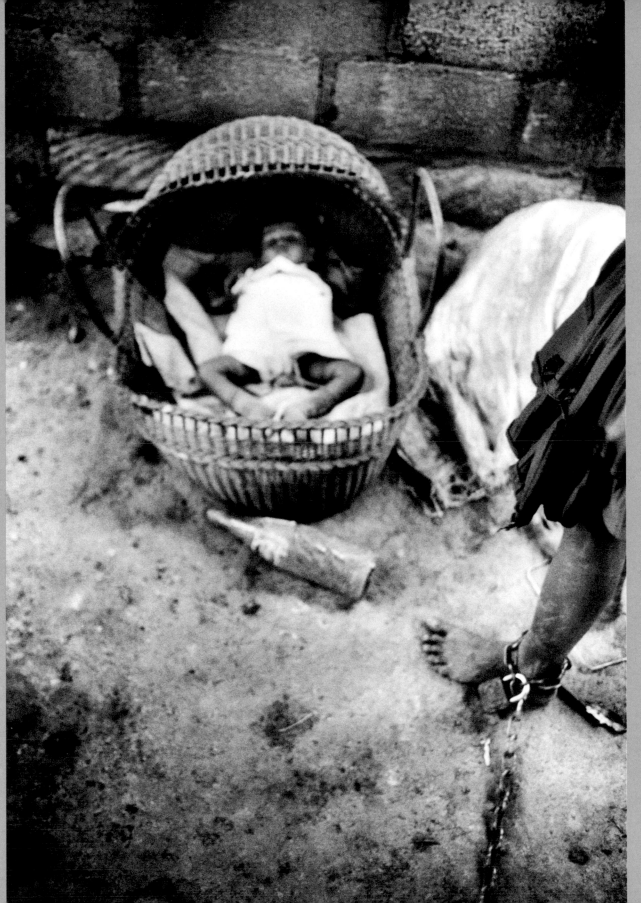

Carolina (15) on the patio
of her mother's house

El Chino's House

El Chino lives by the lake, close to Solomon. Inside his deteriorated house, one cannot stand upright.
Over the years María Coco, Angela, Rosita, and Ysenia have been his girls.
María, Carolina's twin sister, and her son, Freddy, have frequented his house as well.

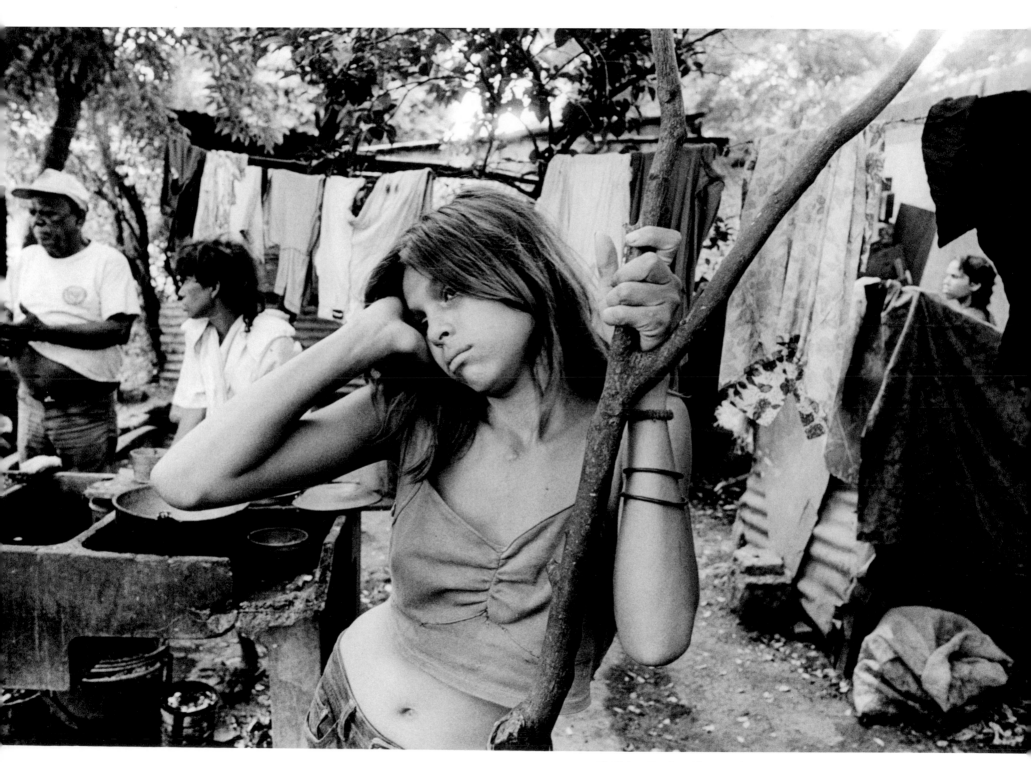

El Chino, Rosita (18), Ysenia (13) and Angela (17) 101

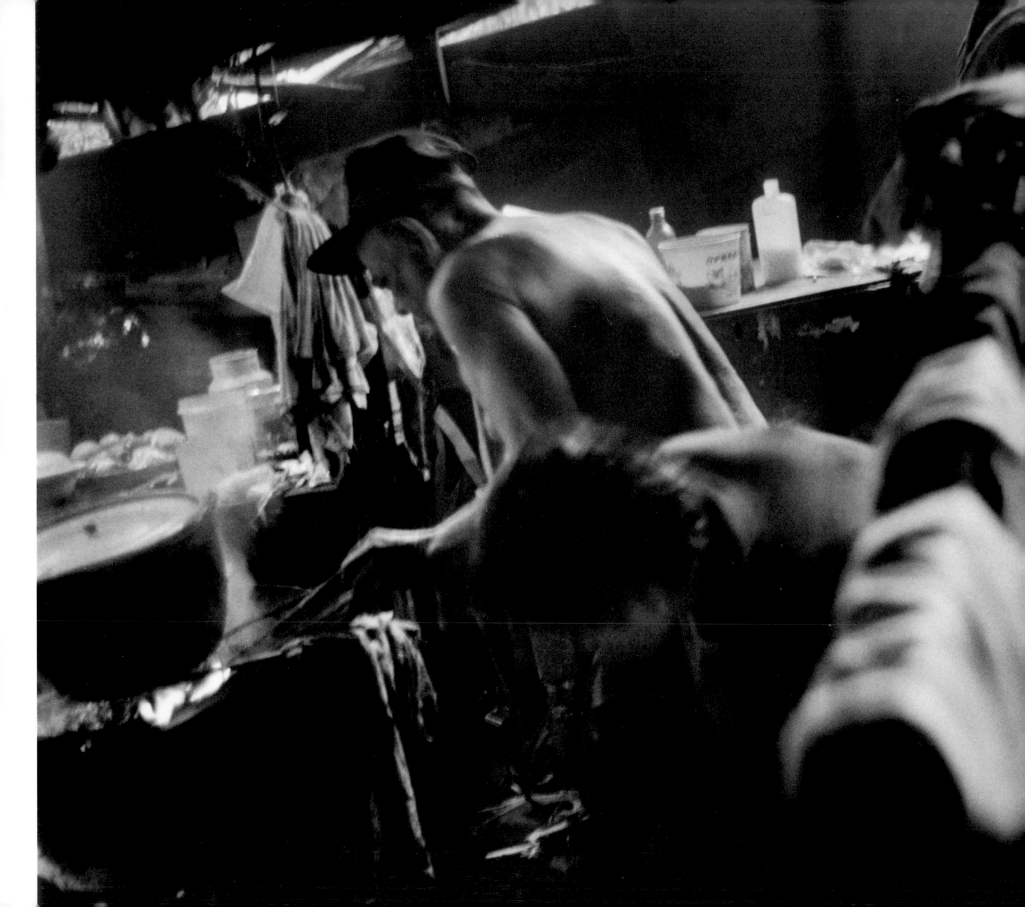

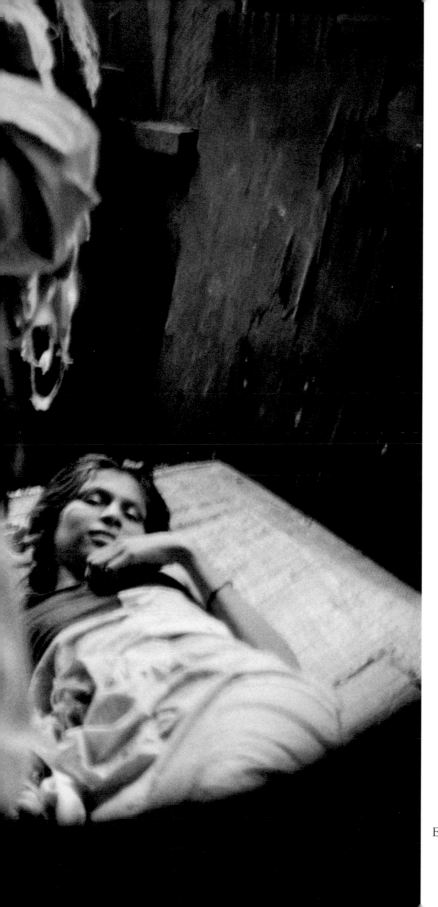

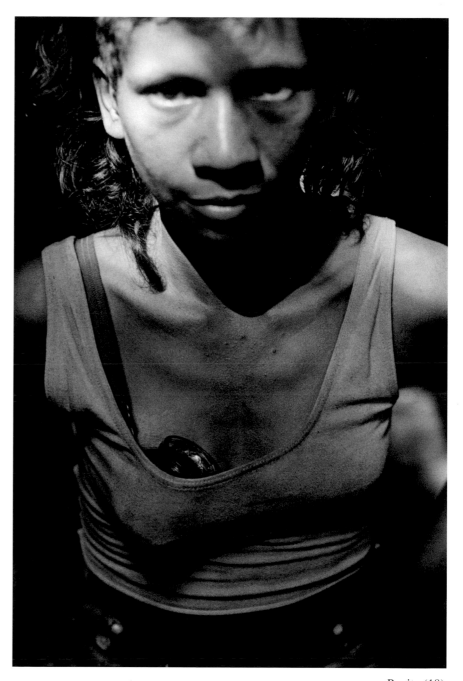

Rosita (18)

El Chino and Ysenia (13)

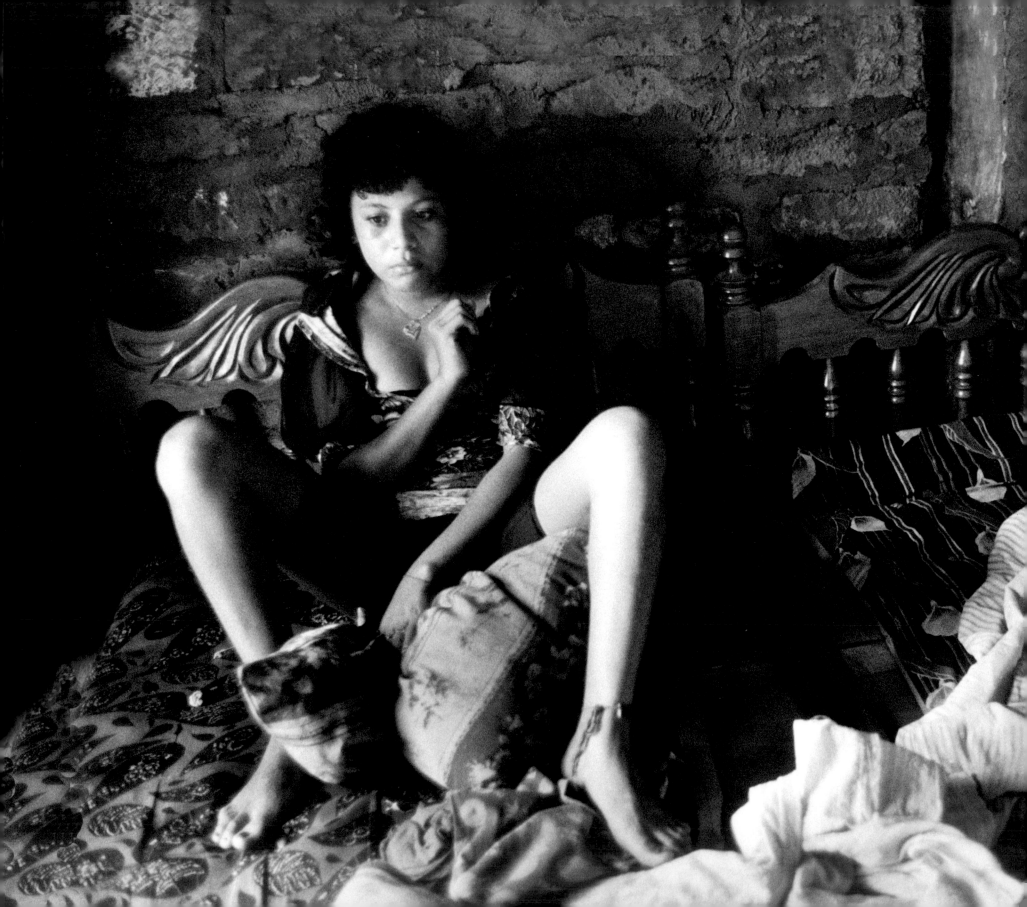

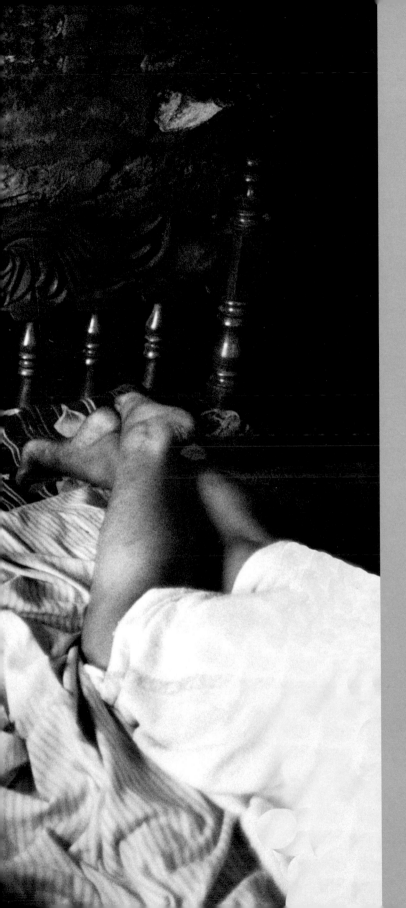

Left: Jaquelín (13)

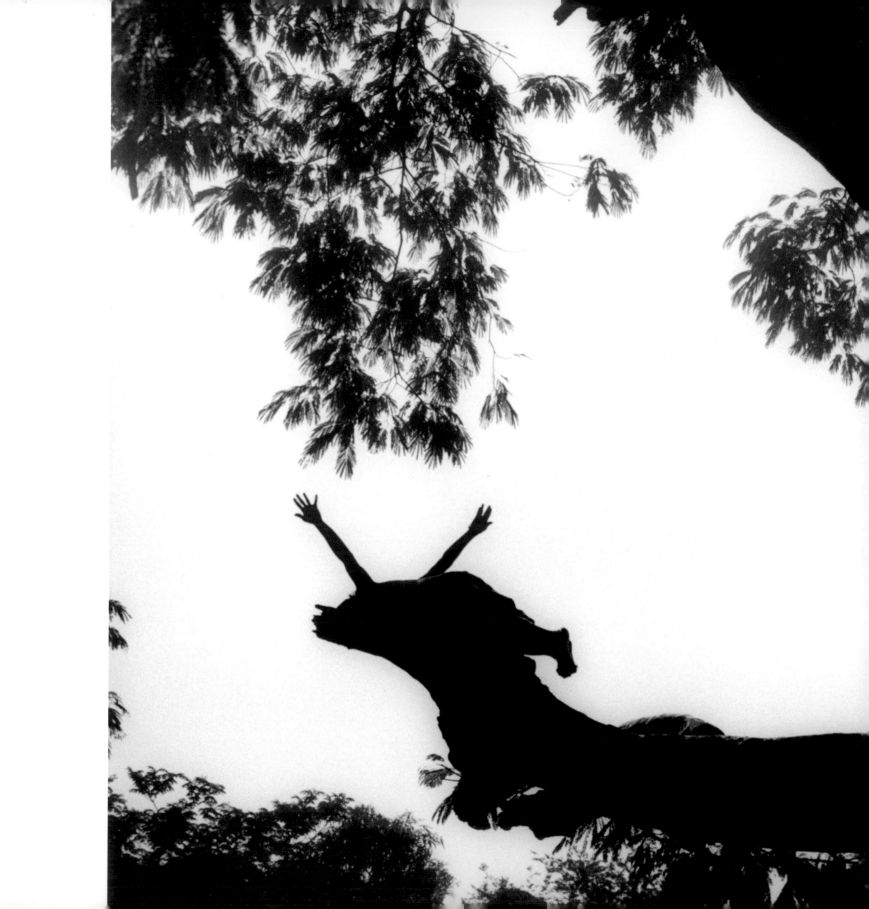

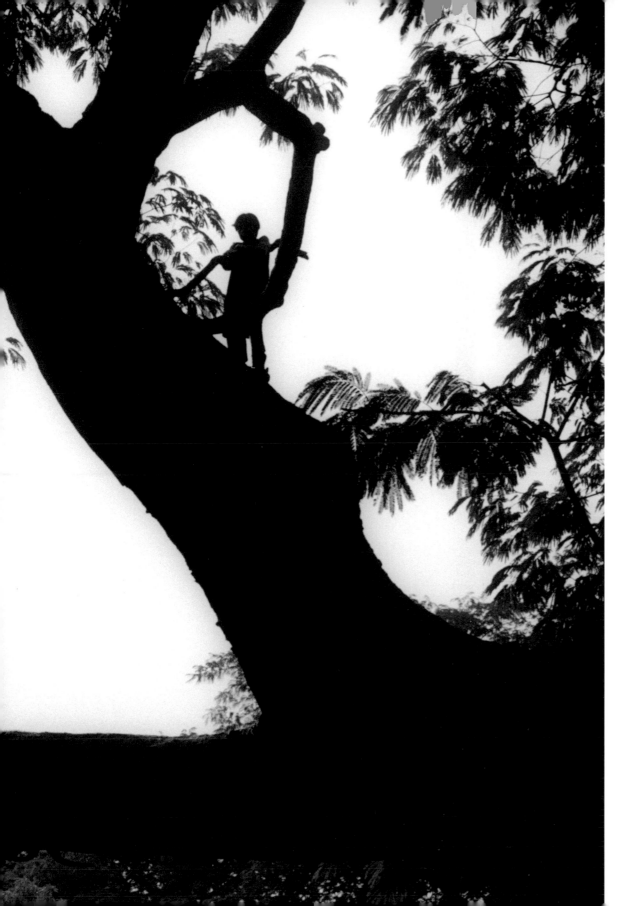

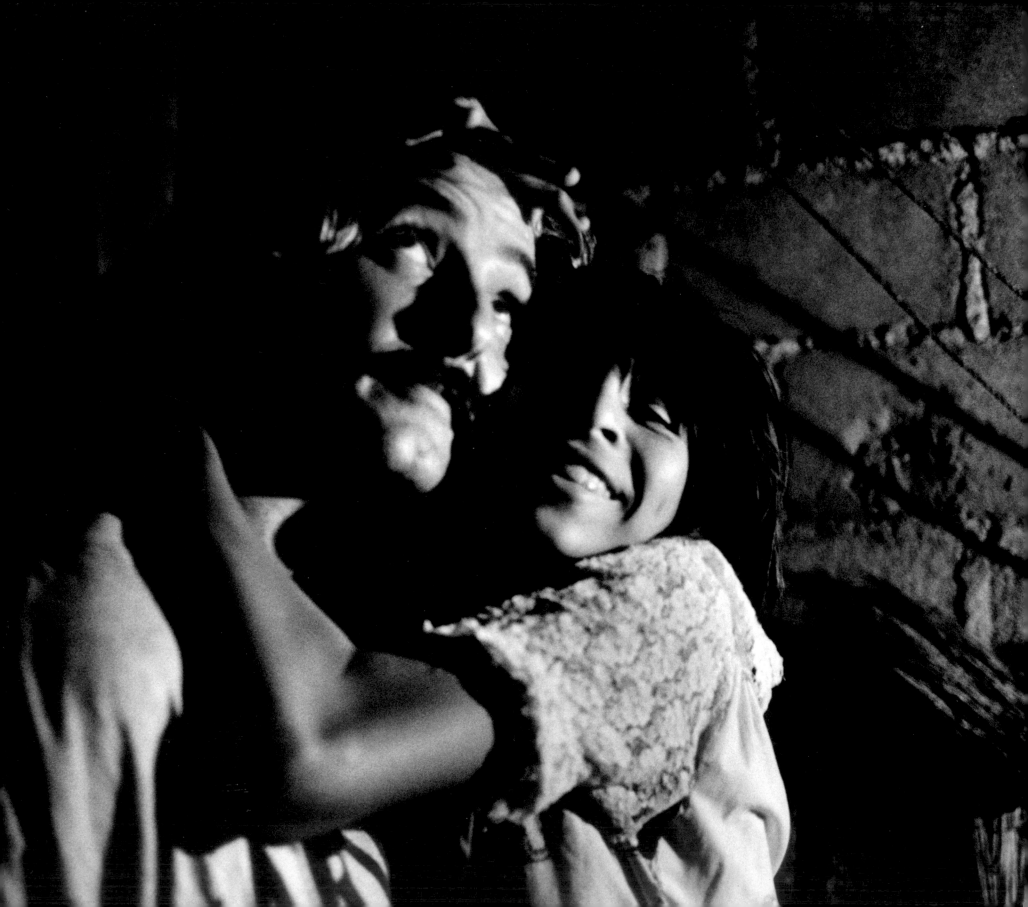

Olivier's House

Olivier's house is different from Don Pedro's, Don Cano's, El Chino's, and Solomon's.
It's not easy to be in Olivier's house. Until now, the child has only received a street education.
They have learned how to survive in a brutal environment; they have learned how glue can calm the fear.
What they have not learned is how to live with peace of mind. If they come to Olivier's house they get the chance
to start a new life. They are not allowed to fight or sniff glue, but they receive a clean bed, a decent meal,
a bathroom, and a better education. Many girls find life in Olivier's house so demanding, that they choose to
return to the "easy" life in the streets.

Previous pages: Boys jump from
the trees to the water.
Left: Olivier and Ysenia (13) 109

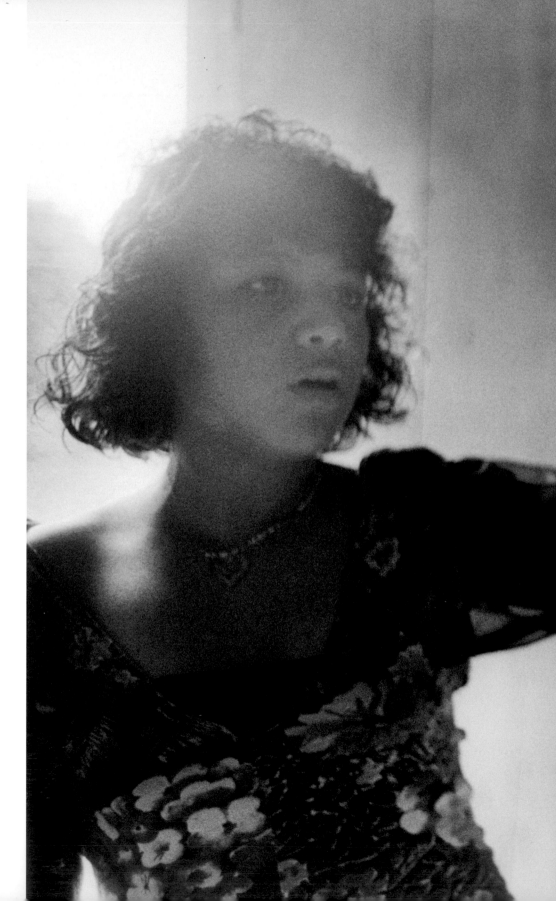

110 Jaquelín (13) and Jenifer (13)

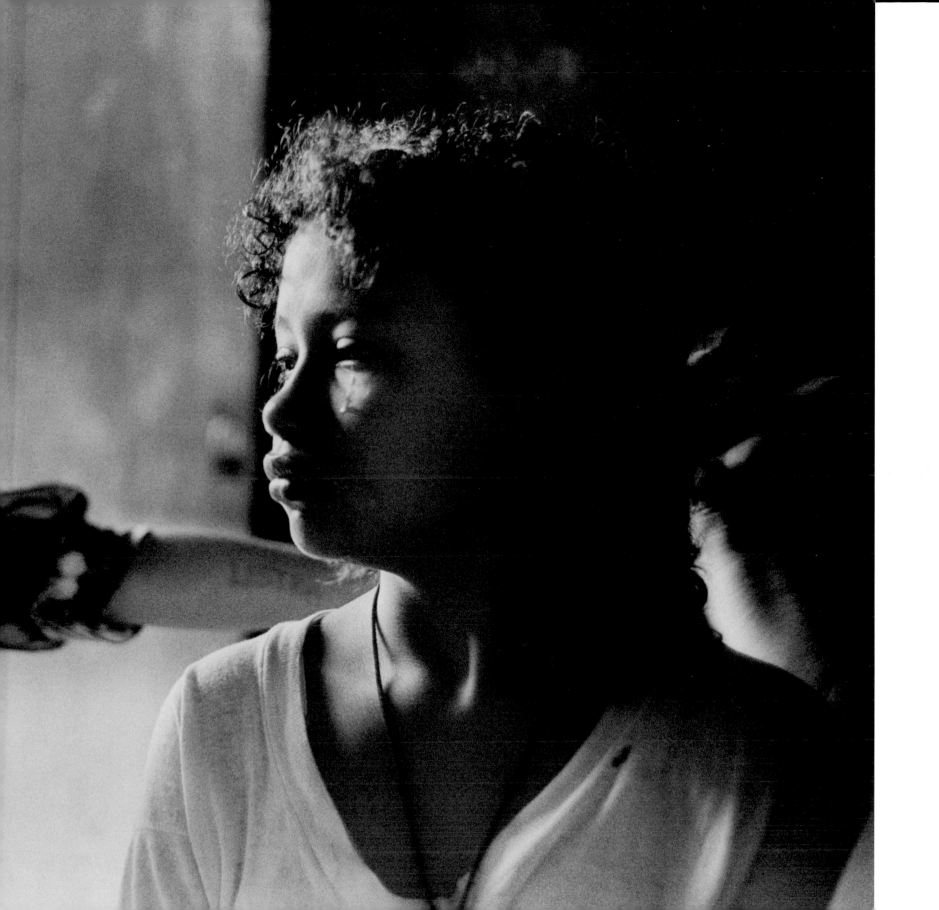

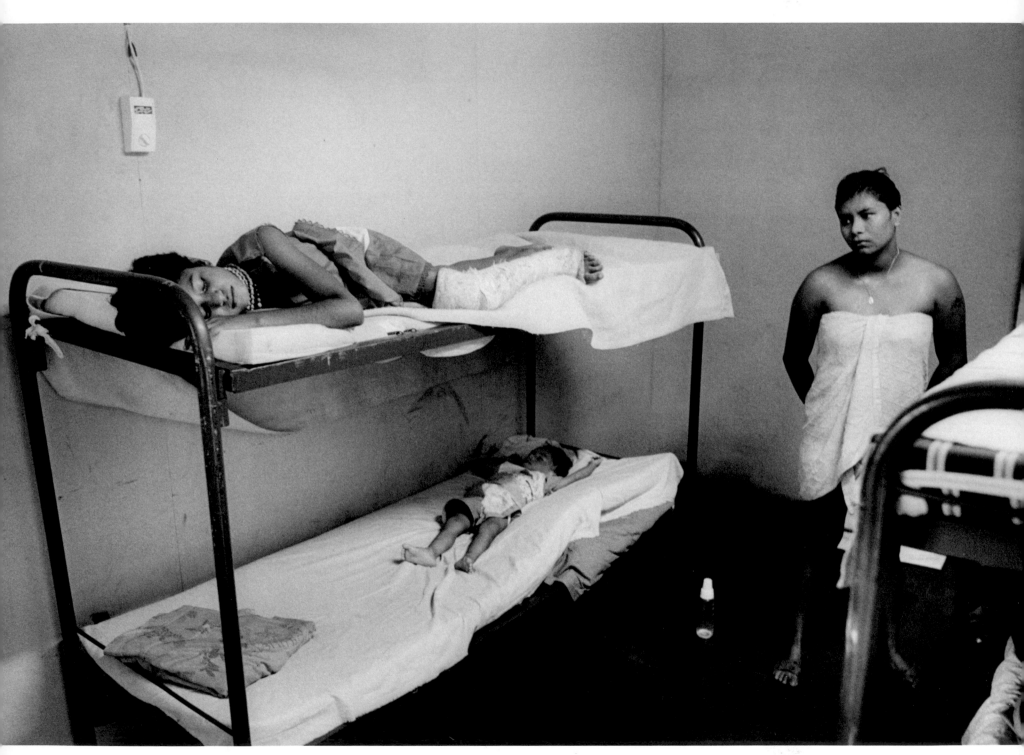

112 Cristina (12) and Ana (15) with Ana's daughter, Carolina

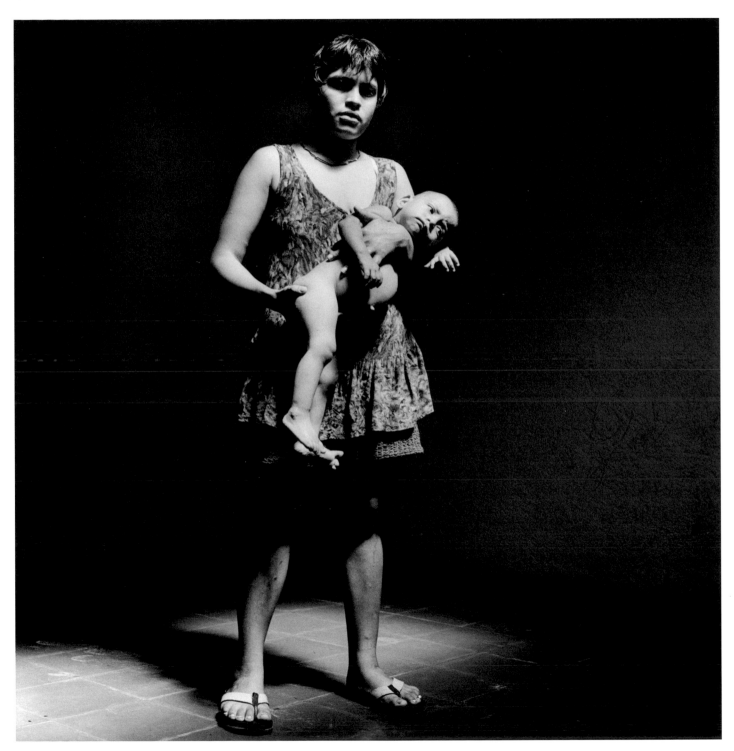

Carla (16) with her son 113

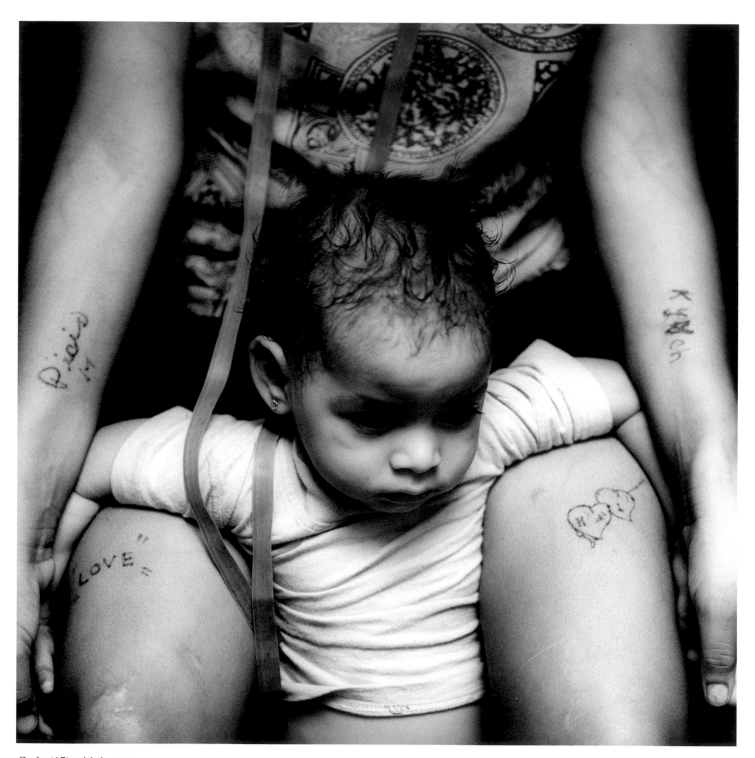

114 Carla (17) with her son

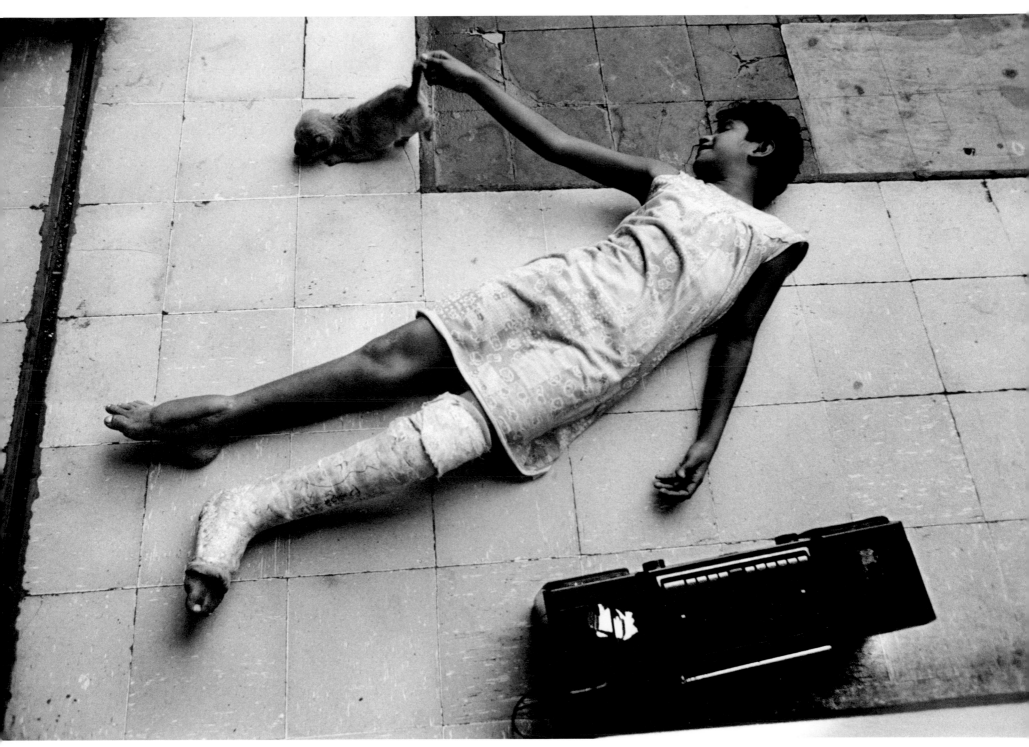

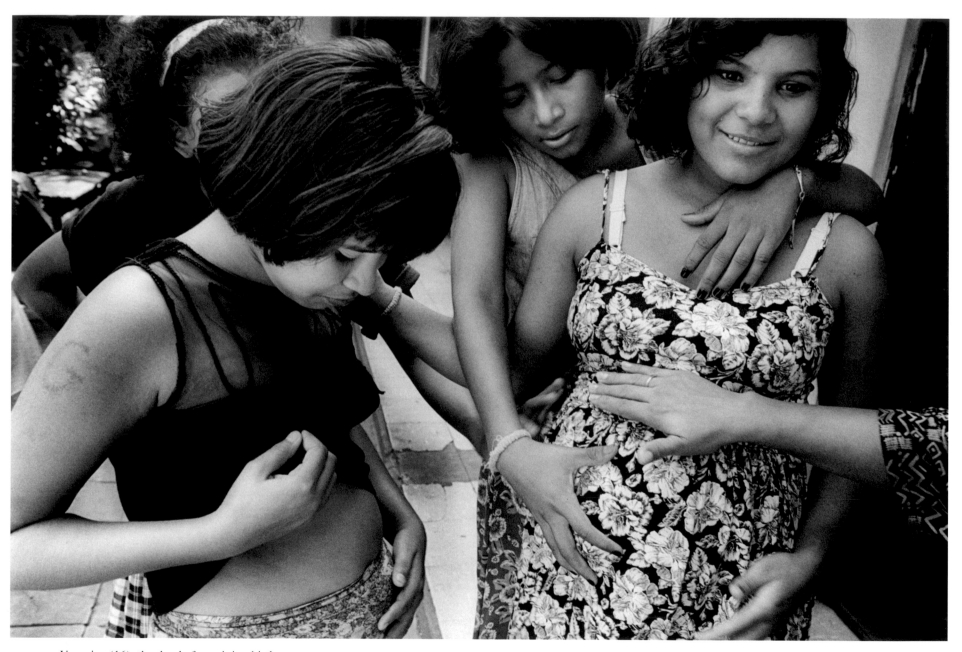

Veronica (16), the day before giving birth

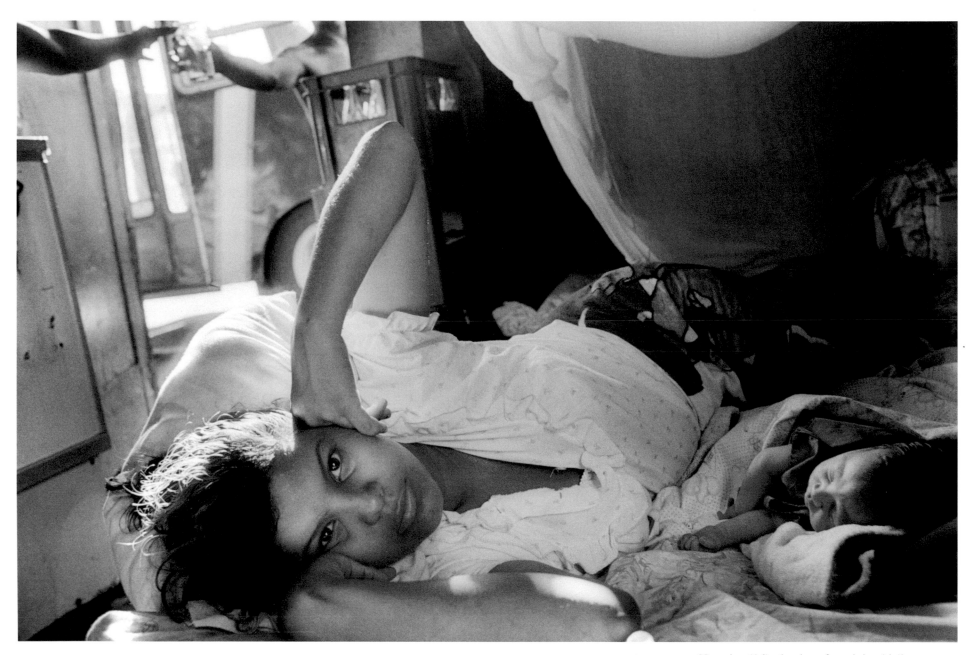

Veronica (16), the day after giving birth

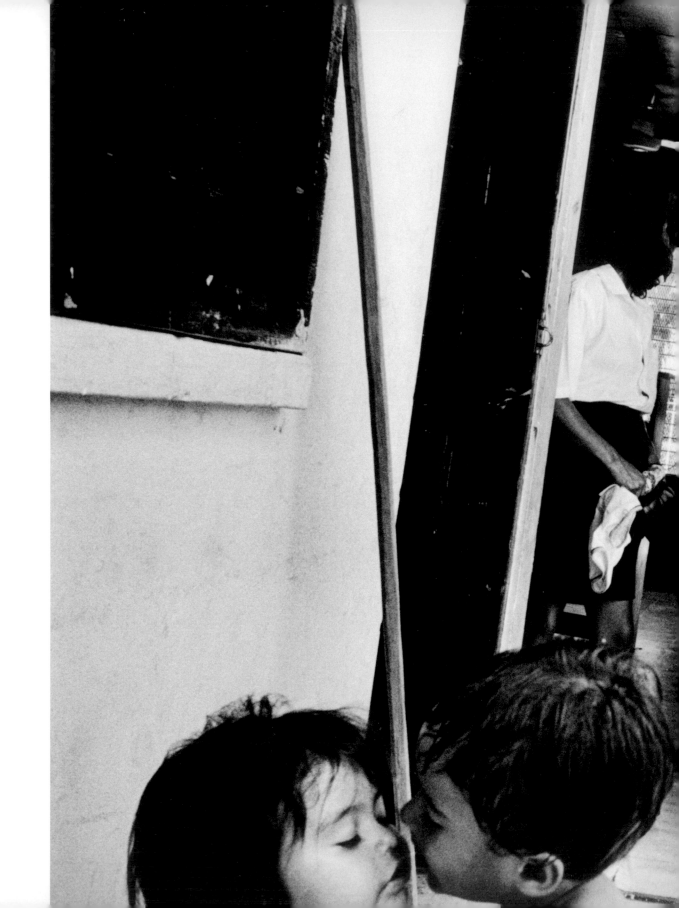

Olivier, an idealist,
has committed his life to helping
street kids in Managua.

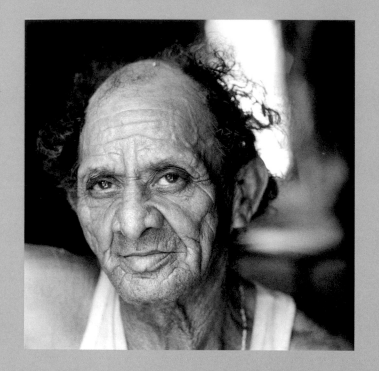

Solomon's House

Solomon is a sixty-year-old fisherman. He lives on the shores of Lake Managua.
Occasionally, he fishes its polluted waters.

Many girls have lived in Solomon's house over the years: Cándida, Angela, Juana, Carmen, Aleyda,
Helinda (La Loba), and María Mercedes. Carmen and Aleyda have stayed an especially long time.

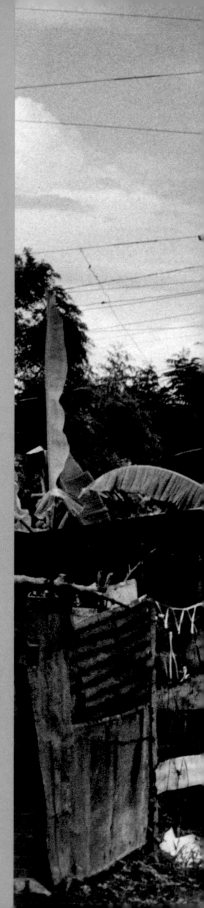

Carmen and Rosita
in front of Solomon's house

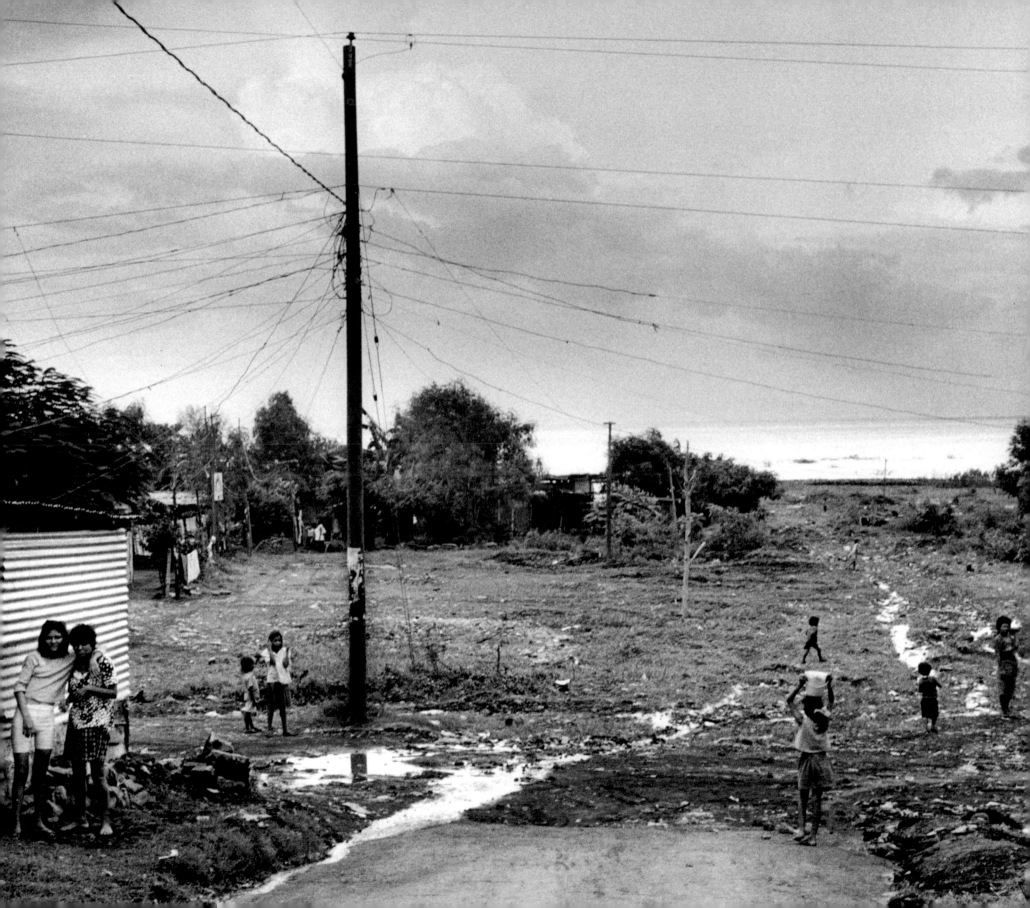

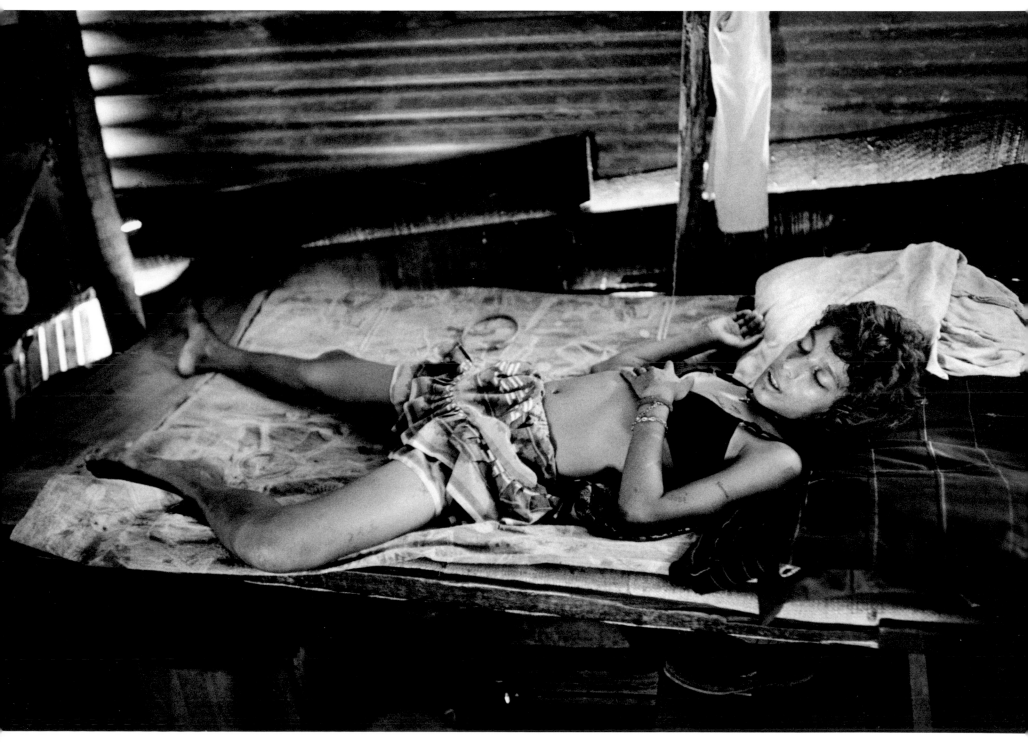

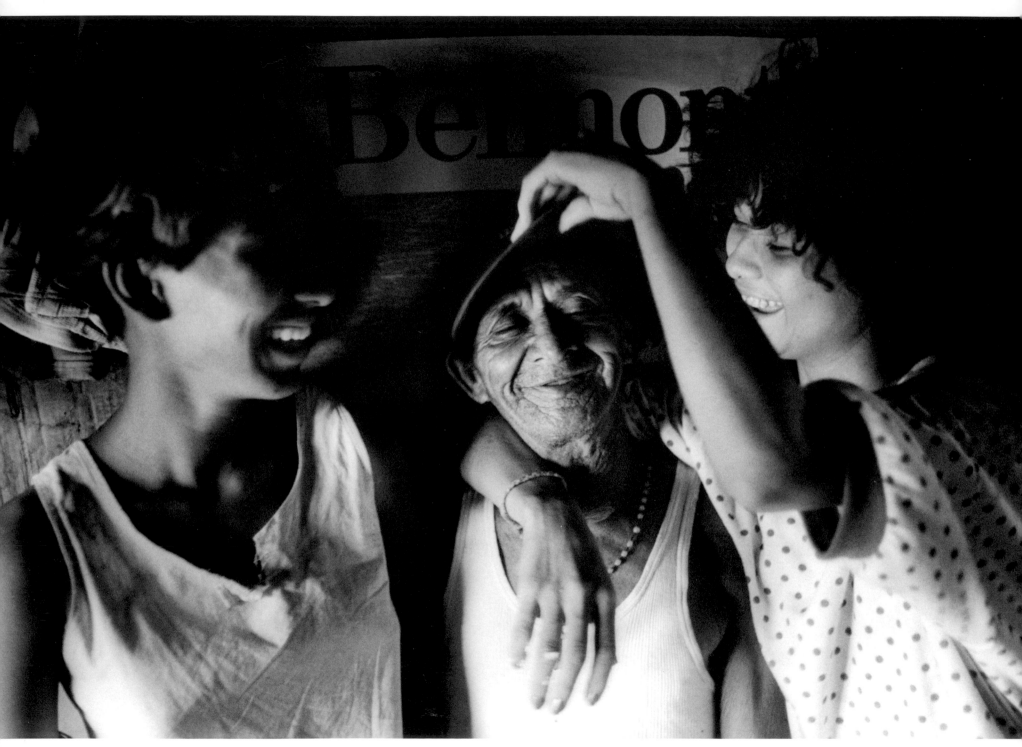

124 Aleyda (14), Solomon, and Carmen (15)

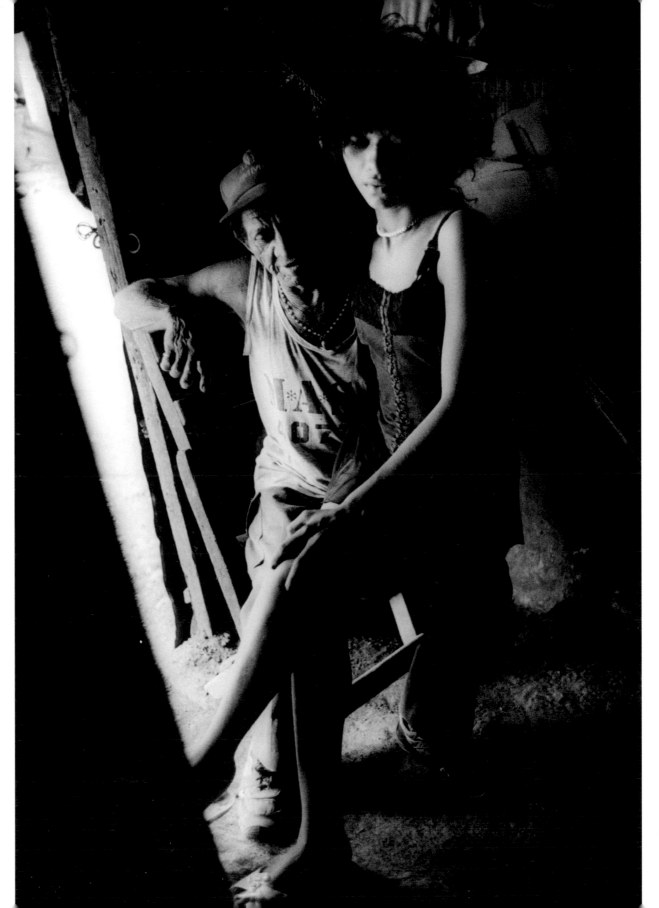

Carmen (16)

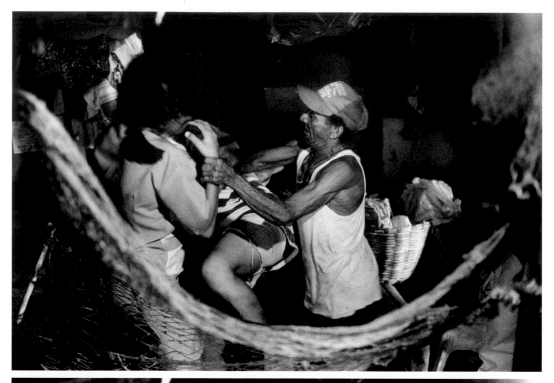

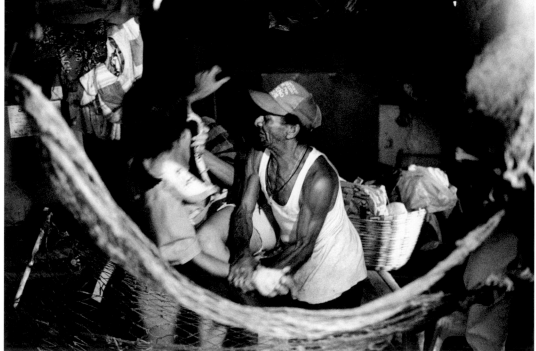

126 *Above and right:* Solomon and Carmen fight as Angela watches.

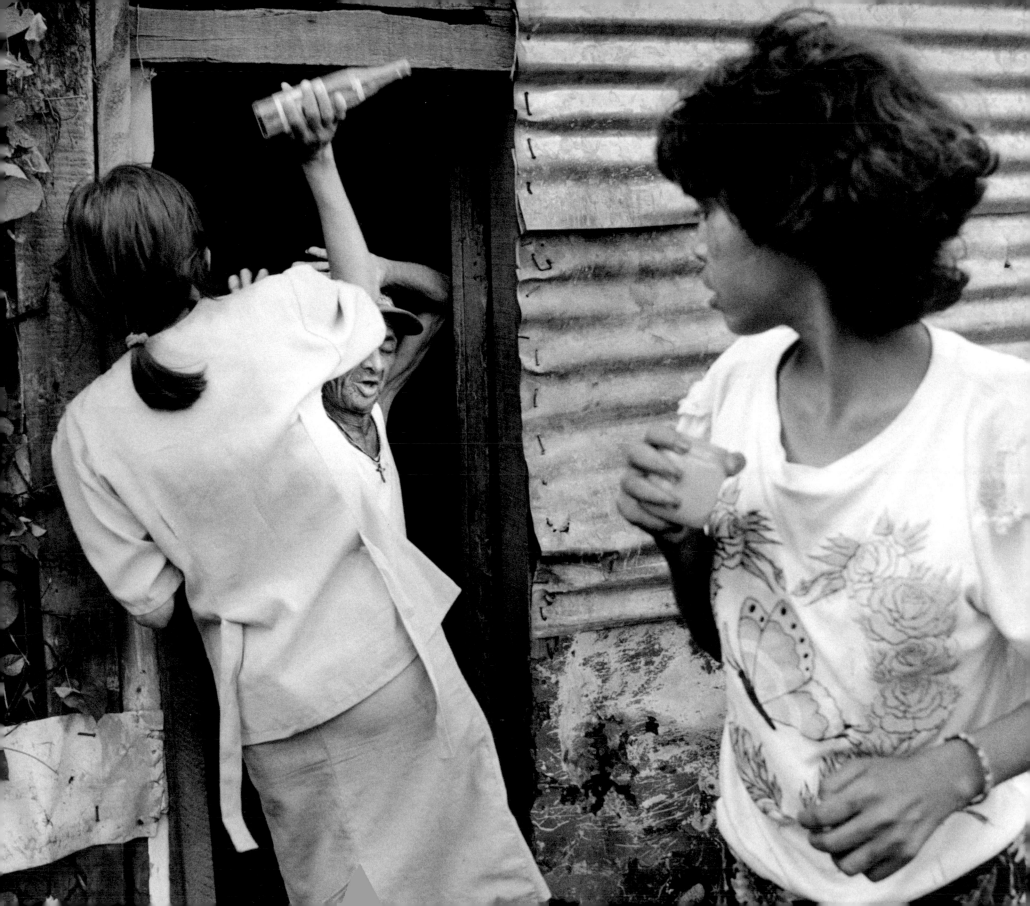

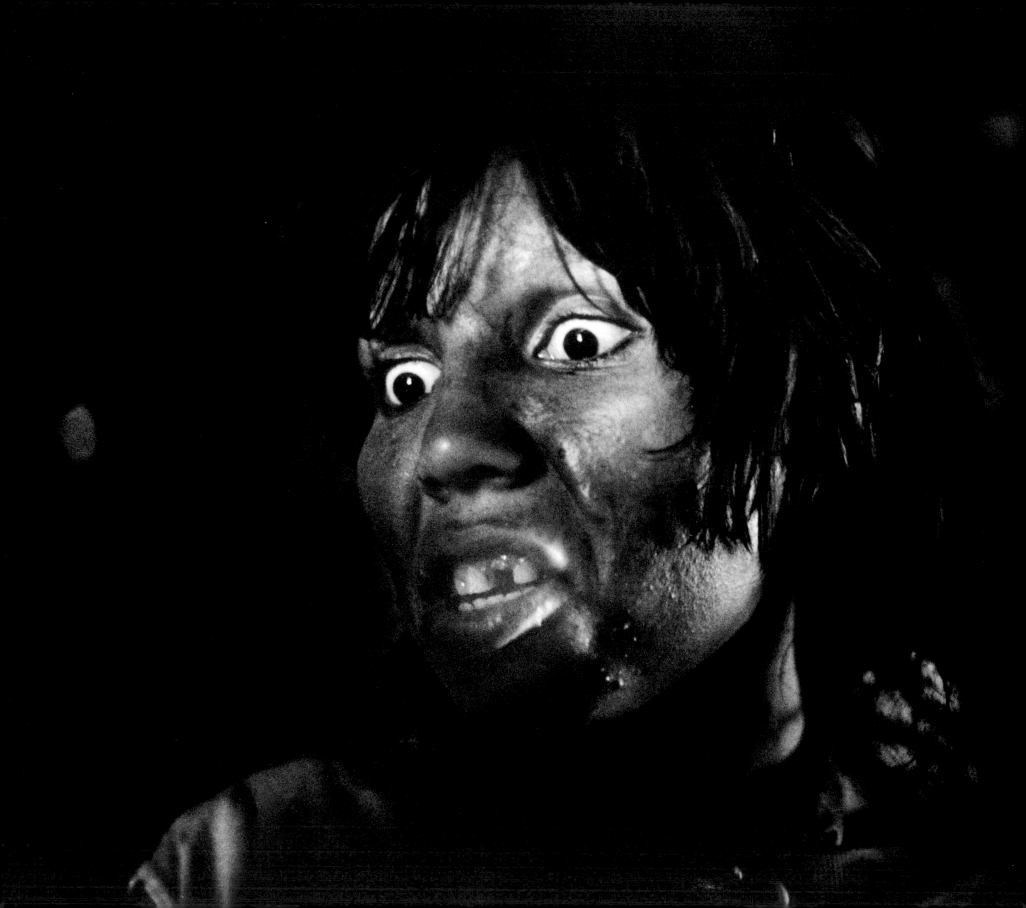

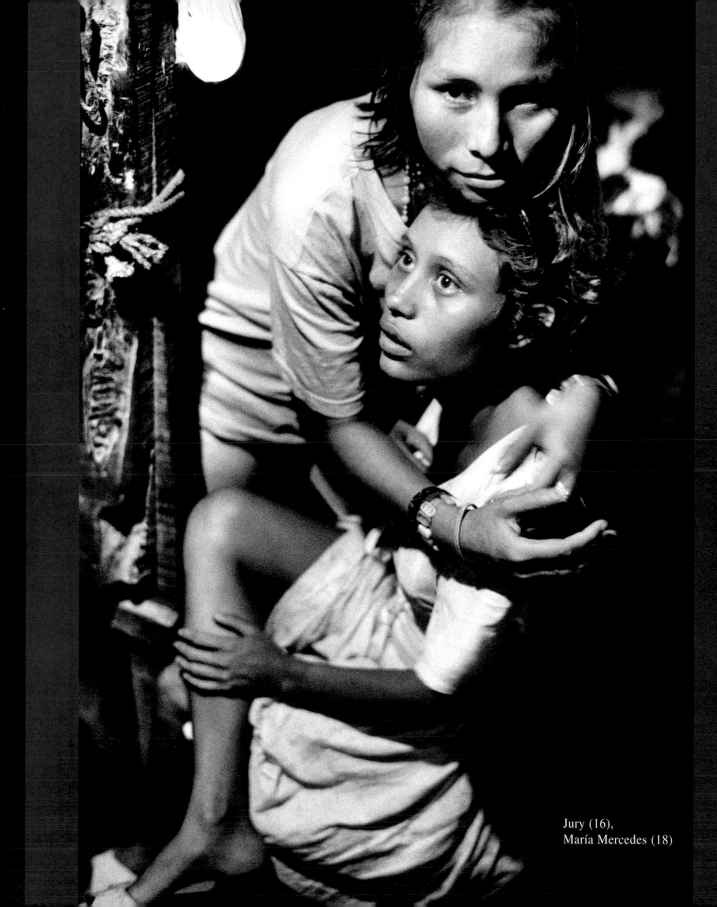

"La Loba" (16)

Jury (16),
María Mercedes (18)

One morning Hurricane Mitch destroyed Solomon's house and he was forced to leave his illegal site at the edge of the lake. The effort he made to move the materials and construct a temporary house for himself and his six girls almost killed him.

The girls sat all day beneath some sheets of roofing, passively following Solomon's efforts to build a new home. Solomon sat down to rest, but instead of getting up, he fell to the ground . . .

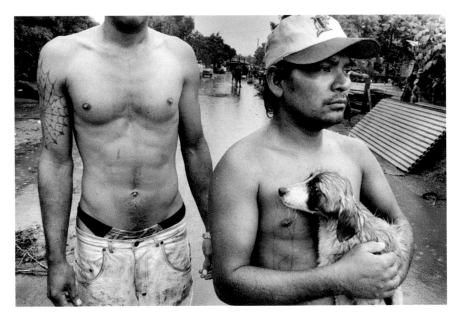

Above: Victims of Hurricane Mitch
Pages 131–135: Solomon's efforts to rebuild his house

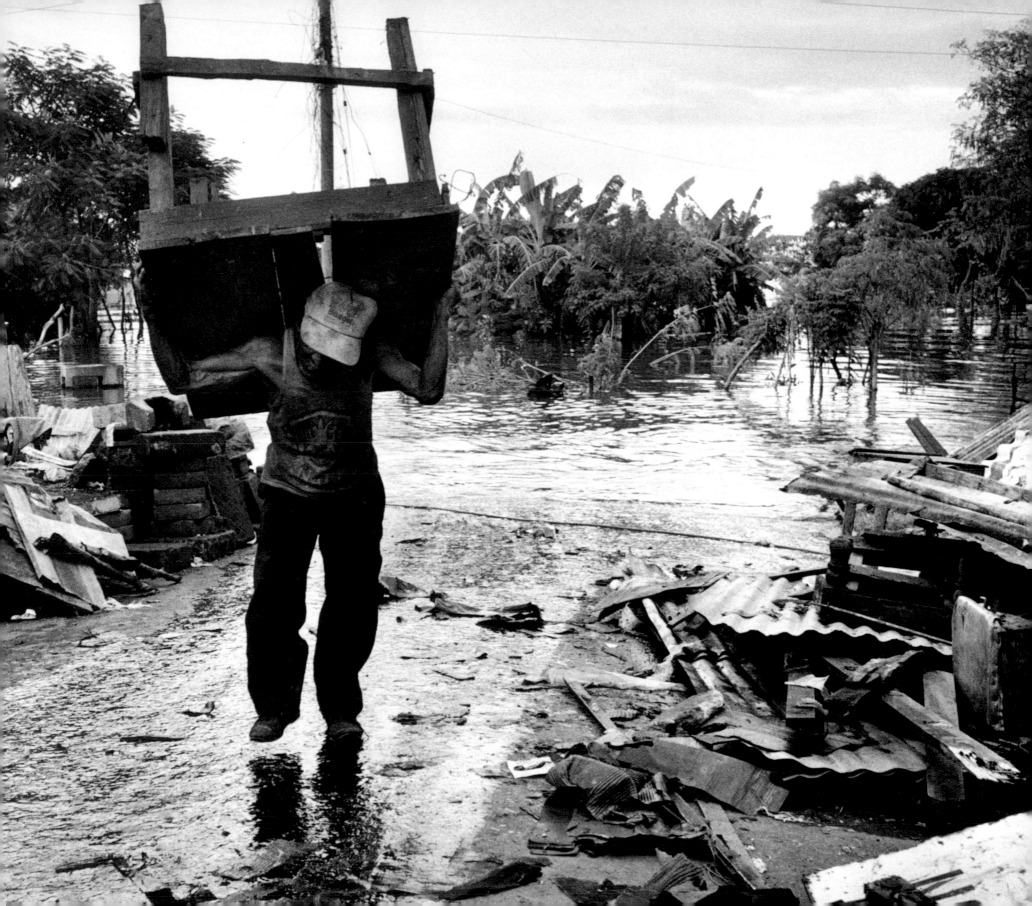

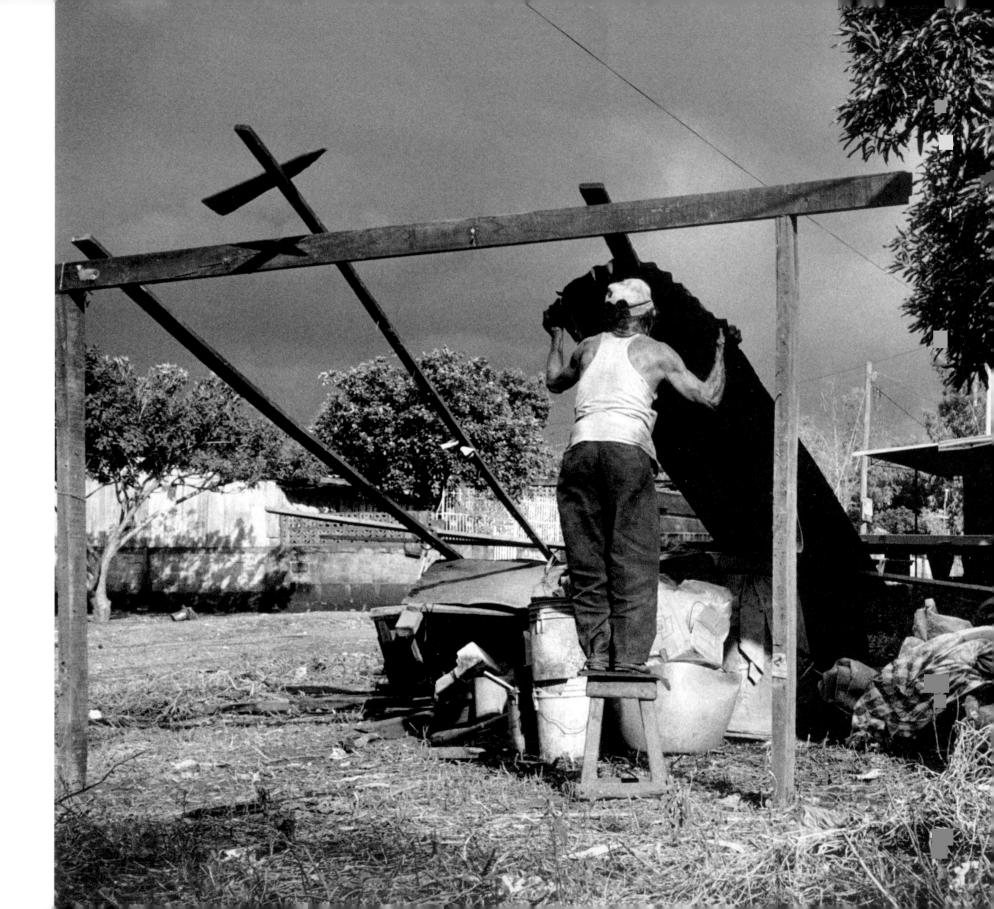

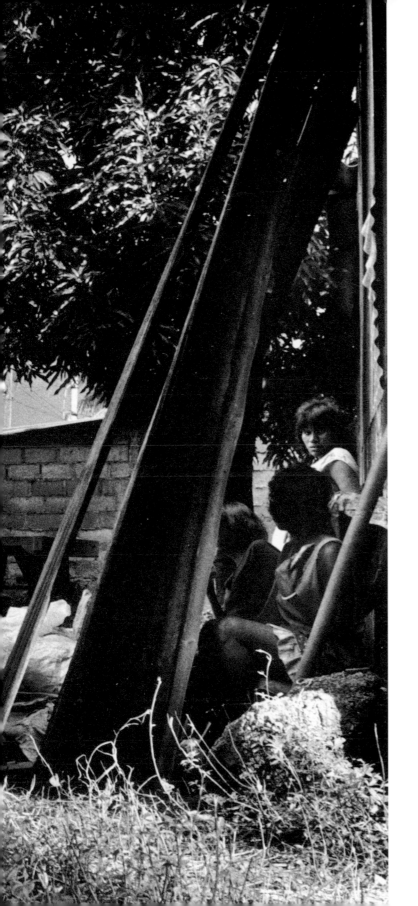

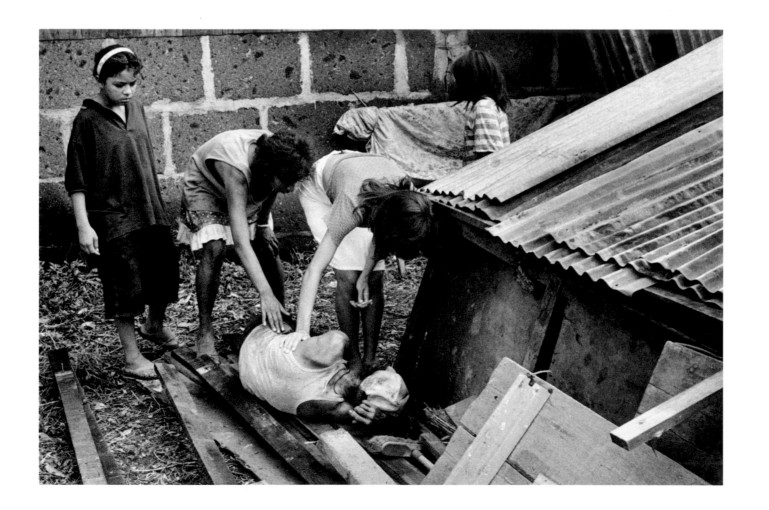

134

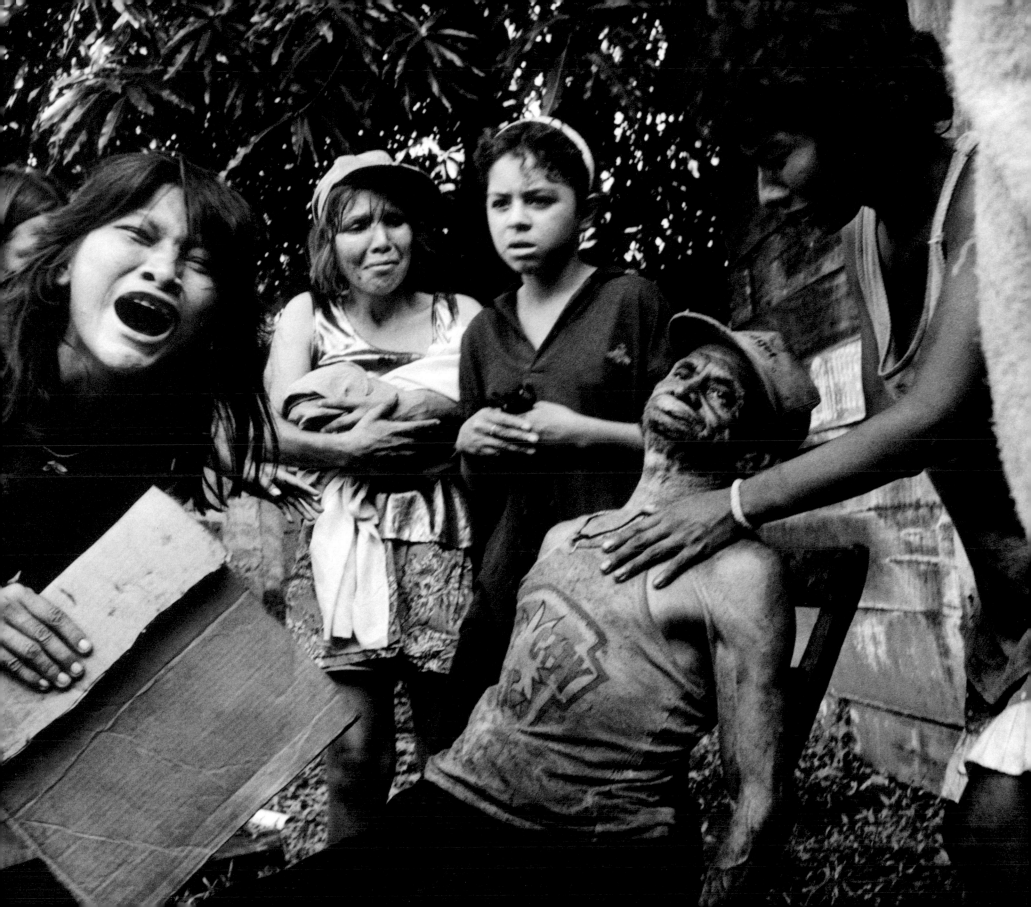

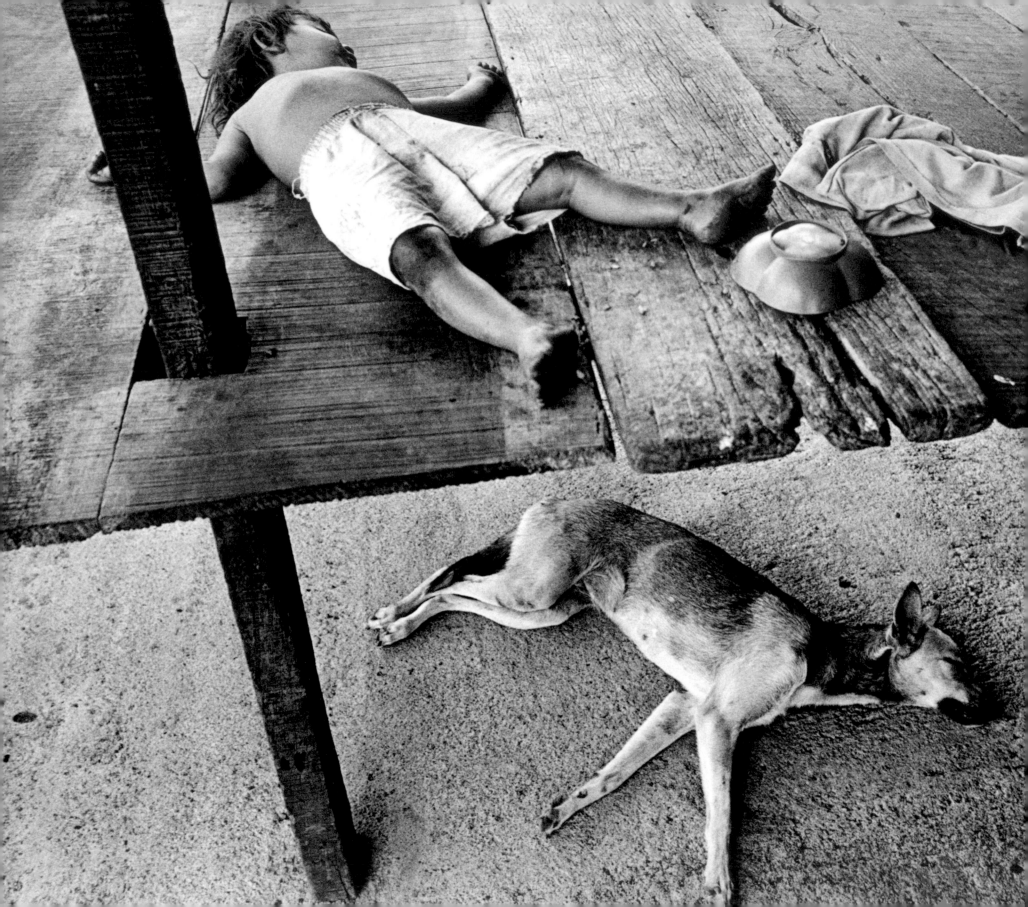

afterword *by Henrik Saxgren*

Does your mother have a job? Yes! She sells water at the market.
Has she had other jobs? Yes! She sold lottery tickets.

The girl speaking is only thirteen years old. She answers a new question—what was the best experience in your life?—with resounding silence. A repetition changes nothing. The answer is still silence.

That silence gives expression to a wretched existence. Pleasant memories are simply not part of the experience of Nicaragua's poor, certainly not of its children.

I first came to Nicaragua in 1984. Five years earlier, an armed revolution attempted to bring social and economic justice to the land: the despotic dictator Somoza and his brutal National Guard were run out by a poorly armed Sandinista guerrilla army with tremendous backing from the general population.

Liberals and humanists the world over flocked to Nicaragua to lend a hand and to soak up the euphoria that had seized the country. The Sandinista government had a program of which only the most hard-hearted would not approve: health and education for the poor. I fell for the euphoric atmosphere.

The country was very poor. The roads were so full of potholes they resembled a lunar landscape. Public transportation was almost nonexistent. Water and electricity were strictly rationed, and there was very little food.

The only thing in abundance was children—clean, happy school children in their white shirts. (How the women in these slum quarters managed to keep those shirts clean is still a mystery to me.)

In 1984 the country was already at war.

An army of counterrevolutionaries, the Contras, trained and paid for by the United States, made life difficult for the new Sandinista government. With daily attacks from across the border in Honduras, they managed to keep the country in an almost permanent state of emergency. A great many workers who could have taken part in the rebuilding of the country were instead sent into the mountains as soldiers.

Of course, there was no foreign investment during this period—that goes without saying. And as the government used more and more of the country's already scarce resources for military defense, the people's continued enthusiasm for the new government stood in glaring contrast to the country's gloomy prospects.

Nicaragua's first election in 1984 provided the Sandinistas with a powerful political mandate, but it was an election over twelve hundred miles to the north that would determine the country's fate. A few days after the Sandinistas' electoral triumph, President Ronald Reagan was reelected to a four-year term in the White House.

From then on, things began to spiral downwards in Nicaragua.

The American trade embargo continued and support for the Contras increased. No measure went untried in President Reagan's crusade against the Sandinista government. The absurdity reached its height when Reagan

went on television to warn the American people that the Sandinista army could reach the southern border of the United States in less than forty-eight hours.

This hypocrisy was without equal and, in the end, tragic. Nicaragua was a poor, politically insignificant country that could not threaten anyone, unless you feared that its social experiment might inspire other poor peoples in the region.

Of course, balance-of-power concerns played a role. The 1980s still belonged to the Cold War era, and the American trade embargo threw the country into the arms of the Soviet Union. But, on the whole, the U.S. efforts to destabilize the country seemed completely out of proportion and were primarily responsible for Nicaragua's social collapse. For the country never got on its feet during the Sandinista regime.

When I returned to Nicaragua in 1987, the poverty was even more pronounced, and the country was in a desperate situation during the 1990 election—hopelessly in debt and trapped in a dead end. In eleven years, the Sandinista regime had managed to raise the general standard of health care, and literacy and educational programs had provided the people with some of the best education in the region. But the people could not take any more; war and poverty seemed to go on without end.

Thousands were killed in the fighting in the mountains, and every family in the country had paid with a son or a daughter. Above all, there was no hope that continued struggle would be of any use. The last to concede defeat were the Sandinista commanders. Yet it is to their credit that they ultimately respected the will of the people and conceded defeat to Violetta Chomorro.

That the Sandinista leaders were corrupt and ended their terms appropriating large amounts of wealth for themselves (Nicaraguans called this phenomenon "La Piñata") does not acquit the United States. Nor does the fact that virtually all the Sandinistas' social improvements later appeared to have been made on borrowed money. The Sandinistas left Nicaragua with a debt of ten billion dollars and an inflation rate of seventeen hundred percent. They had kept their promises about education and health, but had not managed to create a society that could pay for these things.

I was disillusioned and angry when I left for home.

What would the future now bring for these school children in their white shirts?

I never thought I would come to find out, for I could not imagine ever returning.

But I did.

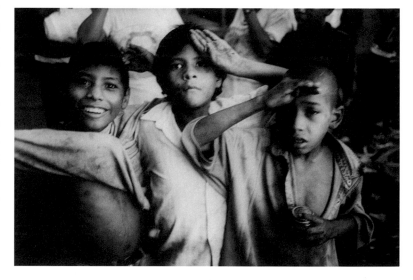

Managua, October 1994

In the fall of 1994, I was invited to Nicaragua along with a Danish delegation that was to participate in ceremonies marking the opening of a cultural pavilion in Managua, paid for by the Norwegian and Danish governments. As we sat in a bar on the first night, we were met by filthy children crawling between our legs and begging for food. It was quite a shock.

I had seen street urchins in other places in the world, and of course they had made an impression, but this

went straight to my heart. I had seen these children in their white shirts with schoolbooks under their arms. I had seen them happy and proud. And now this . . .

Work on this book began that night.

"Olivier!" "Olivier!" The children came out of the darkness and threw their arms around the waist of the Belgian social worker, Olivier Sebrecht. "Papito!" "Papito!" . . . It was night at the Mercado Oriental in Managua, and the shouts resounded every time a homeless boy or girl caught sight of the tall, thin, fair European. Olivier was thirty-five years old and one of the many supporters of the revolution who had come to Nicaragua in 1985 to help with the coffee harvest. Although many supporters went home after the electoral defeat, Olivier had chosen to return to Nicaragua. He and an Italian woman, Zelinda Roccia, took on the job of alleviating the suffering of homeless children. (One of the first things the new government had done after taking power in 1990 was to close most of the institutions and orphanages, and many of these orphans had sought refuge at the Mercado Oriental.)

It was February 1995, and Olivier was to provide me with one of the most intense experiences in my life. Night after night, we wandered the labyrinthine streets and alleys of the great marketplace in the heart of Managua. By day, populated by twenty to thirty thousand people in a chaotic, dusty hell; by night, home to hookers, criminals, night watchmen, and homeless children.

Every night we were visited by Come-Gato, a tall homeless boy who had had his stomach slit in a knife fight the month before. His wound would not close, and Olivier was now his only chance for help. With a patience I will never grasp, Olivier cleaned and bandaged his dreadful, infected wound, while other children came out of hiding and almost patiently stood in line. These children were hungry, afraid, cut-up. They tried to deaden their pain through the virtually constant inhalation of the solvents in epoxy glue.

It was apparent that open wounds had the highest priority, and when a little scamp, hardly ten years old, realized this, he discreetly picked the scab off of an old wound to make the blood flow, convinced that this would move him up in line. A caring touch was just as important for these children as it is for children anywhere else in the world. And Olivier was the only person they knew who cared for them unconditionally.

Night at the market was brutish and ominous, but Olivier walked on hallowed ground. He enjoyed an immunity, which protected me as well, and at no time did we encounter any physical violence.

And then, there were the girls.

Ten-, thirteen-, seventeen-year-old girls, some with an infant in one arm and a glue pot in the other, lived wretched lives in the darkness at the market. A Dante's hell with glue as the only means to dull the fear, the hunger, the pain. How was this possible? I have a daughter myself, fifteen years old at the time, and again and again I was struck by the thought that she would not have survived a night in this place.

Olivier and Zelinda divided the work between them. Zelinda took care of the boys and had opened an orphanage outside the city for them. Olivier concerned himself primarily with the girls and kept a home for girls near the market.

Night at Mercado Oriental —
young girls seek care and
attention from Olivier.

I quickly discovered that we did not wander about at random.

Olivier was always on the lookout for something in particular, even though it never seemed that way. His patience was unique. Almost every night, we found what he was looking for: young girls who had run away from home and whom he wanted to persuade to return.

I especially remember María Coco, perhaps because she was the first. A pretty girl, the same age as my daughter, she would later repeat the same disappearing act many times. We found her late one night in a shack at the market, in a filthy bed with an older man.

What surprised me most was the matter-of-factness with which Don Cano, as the man was called, let us in and the way Olivier treated him and María Coco. There were no recriminations or indignation, and there was no haste. Gently and quietly, Olivier persuaded María Coco to come with us, and Don Cano accepted it.

When I met María Coco a year later, she had a child. I don't think anyone knows whether Don Cano was the father, but that would make no difference. Most fathers in Nicaragua are disinclined to assume their responsibilities.

Take the twins María and Carolina for example. At thirteen, they both became pregnant by the same man. At fourteen, they were mothers. I met them for the first time at night in the market. They were fifteen and carried their toddlers in one arm and glue in the other. They had their little brother in tow.

From the time they were very small, they had learned that they meant nothing, that they were put into this world to satisfy the whims of men. Even those who had not been abandoned by their mothers as illegitimate and had to live, as a result, with grandmothers, aunts, or neighbors, absorbed what their role in society was: they were to make themselves available. From the time they were quite small, they were to help with cooking, watching the children, and attending to the men in the family.

By contrast, in the name of the Virgin Mary, Nicaraguan mothers cultivate a religiously motivated upbringing of their sons; they worship them! In such a highly religious family culture, it is almost impossible for boys not to get a warped view of the opposite sex. From childhood, they are worshiped by their mothers and waited upon by their sisters. It is not strange that they quickly come to expect that women will attend to life's practical details. From there, they are only a hair away from taking sexual servicing as just another given. In a way, the women themselves contribute to laying the foundation for the macho society that is and remains the scourge of their existence.

Among the group of girls I photographed and observed from 1995 until 1999, virtually all of them have the same story: at an early age, they were sexually abused by their fathers, stepfathers, uncles, neighbors, or older brothers. If you ask them for the best memory of their childhood, the answer is silence. Even though they try, their memories are blank.

In the same manner, they break the connection between their bodies and their emotions. They give up feeling. It hurts too much. Every so often, when they are very sad, they need to feel the pain, and to evoke it, they do violence to themselves. Most often, they cut themselves with glass and tattoo over the ugly scars on their skin.

And it is not only the girls. Often the boys' arms are like a lava field, with deep scars whose welts make dreadful patterns in their skin.

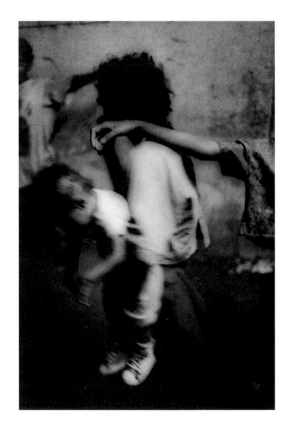

Night at Mercado Oriental— young mothers live wretched lives in the darkness.

140

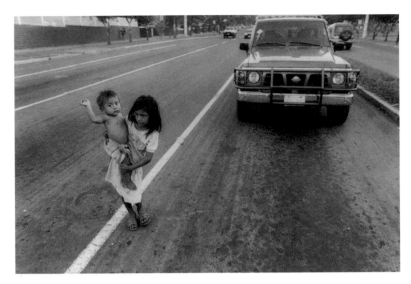

From the time they are quite small, girls are expected to help watch their brothers and sisters.

On successive trips, I refined and developed a method to secure a certain respect for myself at the marketplace. I walked around defiantly; my camera equipment was worth ten thousand dollars, and even though I was almost always together with either Olivier or people from his street team, no one could have prevented it if anyone had decided to steal my equipment. I was in close and direct contact with the young people, but when it came to touching my camera equipment or my pockets, I was without compromise: that is the line, no further! One day in the Callejón de la Muerte, I suddenly felt a hand in my pocket. Instinctively I turned around and struck out at the boy, whom I also knew. I hit him fairly solidly on the back of the head with my palm.

This boy, who had received hundreds of blows and kicks in his tattered life, went into shock. In a trance-like state, he began manically and recklessly cutting his arm with a piece of glass that he had found on the ground. And I could not make him stop; I could not reach him.

Fortunately the piece of glass was rather dull, and with the help of some of the others we finally brought him out of his trance, but the experience moved me deeply. From then on, I was just another adult from whom he had expected love and who had let him down.

The Callejón de la Muerte, "Death Alley," is the red-light district at the market. On a cardboard sign at one end, you are welcomed by the words: "With God, the impossible is made possible." Outside their small shacks, prostitutes sit in a row—single mothers in desperate economic straits. In Nicaragua there is no social welfare at all. Prostitution is often the only way out in a country with an official unemployment rate of over 50 percent.

Doña Chila, a large, buxom woman weighing more than two hundred pounds, is the Mama of the street. Nobody works on her street without her blessing. She very likely has things weighing on her conscience that will not be counted on the plus side of St. Peter's ledger, but it is not the easiest job in the world she has undertaken. Still, there is order on the street and great tolerance displayed. As opposed to many other places at the market, street children are tolerated here; in a somewhat unfortunate way, the two groups have become a help and inspiration to each other.

The homeless girls observe the adult prostitutes' relative well-being, and begin to dream of being taken under Mama Chila's wing and getting their own shack. Meanwhile, the prostitutes watch how children endure the fear and the pain by anaesthetizing themselves with glue. So today it is not unusual to see an adult prostitute sniffing glue as well.

It is night in Caratera Norte. The girls are standing along the walls surrounding the Victoria brewery in their short skirts. Not all of them have had equal success with their makeup, but who can see in the dark? Cars circle by, occasionally one stops, but it is rare that my kids have a chance in this game. They are not the

only ones offering sexual services. Girls from other social milieus are also walking the street, and their makeup was put on in front of a real mirror with electric lights. Their tight dresses are clean and fashionable, and they don't smell of epoxy glue.

Hundreds of girls walk along the great avenues of Managua. Their client base is apparently well established, for they stand there every evening and, in the gleam of automobile headlights, the girls seem attractive, beautiful. However, the most exotic walk the street between the Hotel Inter Continental and the military hospital. Night after night, they blow kisses to the passing cars but receive only mocking jeers and humiliation in return. That is the lot of the transvestite in macholand.

In Caratera Norte, the number of girls begins to thin out. The most attractive have driven off with customers in expensive cars, and the most wretched have come searching at the market behind the brewery. There they may find a taxi driver or night watchman who will pay five cordobas for a poke. And five cordobas is what a pot of glue costs. Thus, five cordobas becomes the precise dividing line between a good night and a bad night. With five cordobas in your hand, you can buy glue—and the night is not nearly so intimidating with a pot of glue.

Pots of epoxy glue are openly sold by the shoemakers at Mercado Oriental.

It is morning at Solomon's house. Cándida is still asleep. The night had almost become day before she found her way to her shack by the lake. Solomon sits in the doorway, mending his nets. He is about sixty years old and occasionally puts food on the table by fishing. Five or six girls from the market live in his tiny house. The acrid smell of glue hangs in the air as the girls begin to wake up in their hammocks and on their pieces of cardboard. Carmen tries to press a little milk from her starved breasts, so she can feed her fourteen-day-old baby, who has just woken up on his piece of cardboard.

La Loba is angry, which quickly alters the mood, and before Carmen can get the baby fed, she finds herself in a raucous fight with La Loba.

As usual, Solomon intervenes. He is a small man, slightly over five feet tall, and since 1995 he has kept about ten different girls in his shack, which sits illegally on a plot of land close to Lake Managua. Too close to the lake, it would appear.

In 1998 Nicaragua was hit by torrents of rain from Hurricane Mitch, and for several days the lake rose far above its normal level. Solomon's house was caught up in the mass of water. The girls were paralyzed and could only watch as Solomon tried to save what could be saved. Entirely on his own, the little man dragged the pitiful remains of his shack one hundred yards farther up the road, where he began to rebuild his miserable existence.

If I ever believed that the relationship between Solomon and his girls could be explained purely as a matter of cynical sexual exploitation, I now had to revise those views. The girls, who had been sitting all day beneath the shelter of some sheets of roofing, passively following Solomon's efforts, suddenly became uneasy. Solomon had sat down on a box to rest, but instead of getting up again he fell to the ground with a thud.

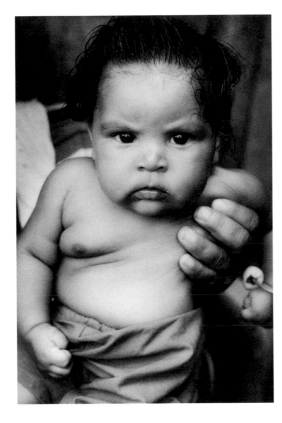

El niño. A male baby is born into a culture infused with machismo.

As an adult, he will take women's sexual services as a matter of course.

When the girls discovered that Solomon was dying before their eyes, it suddenly became crystal-clear that, to these girls, Solomon had been more than a brutal old man who abused them sexually. Paradoxically, Solomon had also been a father figure to them. No one who saw the look of panic and desperation on these girls' faces as a heart attack threatened to provide Solomon with some peace at last, could ever be in doubt about it. As for me, it would be my last experience with the girls.

That day, by Lake Managua, the final piece fell into place.

Others may have reached this conclusion more quickly, but it took me more than four years to come to understand that the girls' desperation was due to their need for a father. The unfortunate thing is that for girls in Nicaragua, sexual services may be the price one pays for fatherly comfort.

Nicaragua is, to be brutally frank, a land without fathers, and one possible explanation may be found in its history. Not only was Indian culture destroyed by the Spanish conquest of the continent, but the seeds of a new culture were sown. For the Spaniards not only murdered and plundered, they raped the country's women and left behind a whole generation of bastards; and bastards are seldom acknowledged.

This crime lies deep within Nicaraguan culture; an affliction.

If you want to understand the abuse and injustice visited upon these children, this is a probably a good place to start looking for an explanation. For just as research studies in the West have indicated that mothers who have experienced incest themselves will more often than not discover that their own daughters have become the victims of incest, it can be said that a similar vicious circle had been the scourge of Nicaragua: bastards beget bastards.

It is not only among the poorest of the poor at the marketplace that fathers flee their responsibility. Of all the countries in the world, Nicaragua has the highest number of single-parent families. Fifty percent of the country's women live alone with their children. The situation is no different with the families of the well-to-do and well-educated. Their children grow up with nannies as their closest nurturers and their parents as absent patrons.

The Danish family expert Jesper Juul has looked into the need for positive role models in a child's development. He maintains that children are from birth equipped with the possibility of acquiring any conceivable character trait, but only those traits they find mirrored in their environment actually emerge in their character. Against this background, growing up in the Mercado Oriental is clearly devastating. The widespread prostitution among poor single mothers in Nicaraguan society is often a final, desperate attempt to support a hungry family. Thus, in a society in which prostitution may be an expression of motherly concern and in which fatherly attention may be purchased with sex, it is not difficult to imagine the sort of demeaning development children may experience.

Today, even Nicaragua's former president, the Sandinista revolutionary hero Daniel Ortega, has some serious explaining to do. His stepdaughter accuses him of having sexually abused her since she was eleven years old.

In 1979, when Nicaraguans finally took on their historic and human responsibility and began to revolutionize this degraded, poverty-stricken society, the children were betrayed. First and foremost by the American president and his administration, but, in the end, by their own leaders as well. ∎

This publication is made possible by the generous support of The Hasselblad Foundation, Sweden, and Ny Carlsbergfondet, Denmark.

Library of Congress Catalog Card Number: 00-103936
Hardcover ISBN: 0-89381-920-4
Separations by Sele Offset, Turin, Italy
Printed and bound by Grafiche SiZ s.r.l., Verona, Italy
Book and jacket design by Dawn Rogala

The Staff at Aperture for *Solomon's House:*
Michael E. Hoffman, Executive Director
Michael L. Sand, Executive Editor; Mary Walling Blackburn, Assistant Editor
Stevan A. Baron, V.P., Production; Lisa A. Farmer, Production Director
Olga Gourko, Design Work-Scholar; Paige McCurdy, Production Work-Scholar

Aperture Foundation publishes a periodical, books, and portfolios of fine photography and presents exhibitions worldwide to communicate with serious photographers and creative people everywhere. A complete catalog is available upon request. Aperture Foundation, including Book Center and Burden Gallery: 20 East 23rd Street, New York, New York 10010. Phone: (212) 505-5555, ext. 300; Fax: (212) 979-7759; E-mail: info@aperture.org. For Customer Service, contact: Phone: (212) 598-4205; Fax: (212) 598 4015; Toll free: (800) 929-2323; E-mail: customerservice@aperture.org. Aperture Book Center in Millerton, New York: Phone: (518) 789-9003. Visit Aperture's website: www.aperture.org.

Aperture Foundation books are distributed internationally through:
CANADA: General/Irwin Publishing Co., Ltd., 325 Humber College Blvd., Etobicoke, Ontario, M9W 7C3. Fax: (416) 213-1917.
UNITED KINGDOM, SCANDINAVIA, AND CONTINENTAL EUROPE: Robert Hale, Ltd., Clerkenwell House, 45-47 Clerkenwell Green, London, United Kingdom, EC1R OHT. Fax: (44) 171-490-4958.
NETHERLANDS, BELGIUM, LUXEMBURG: Nilsson & Lamm, BV, Pampuslaan 212-214, P.O. Box 195, 1382 JS Weesp, Netherlands. Fax: (31) 29-441-5054.
AUSTRALIA: Tower Books Pty. Ltd., Unit 9/19 Rodborough Road, Frenchs Forest, Sydney, New South Wales, Australia. Fax: (61) 2-9975-5599.
NEW ZEALAND: Southern Publishers Group, 22 Burleigh Street, Grafton, Auckland, New Zealand. Fax: (64) 9-309-6170.
INDIA: TBI Publishers, 46, Housing Project, South Extension Part-I, New Delhi 110049, India. Fax: (91) 11-461-0576.

For international magazine subscription orders to the periodical *Aperture,* contact Aperture International Subscription Service, P.O. Box 14, Harold Hill, Romford, RM3 8EQ, United Kingdom. One year: $50.00. Price subject to change. Fax: (44) 1-708-372-046. To subscribe to the periodical *Aperture* in the U.S., write Aperture, P.O. Box 3000, Denville, New Jersey 07834. Toll-free: (800) 783-4903. One year: $40.00. Two years: $66.00.

First Edition
10 9 8 7 6 5 4 3 2 1